The Thing

A Phenomenology of Horror

The Thing

A Phenomenology of Horror

Dylan Trigg

Winchester, UK
Washington, USA

First published by Zero Books, 2014
Zero Books is an imprint of John Hunt Publishing Ltd., Laurel House, Station Approach,
Alresford, Hants, SO24 9JH, UK
office1@jhpbooks.net
www.johnhuntpublishing.com
www.zero-books.net

For distributor details and how to order please visit the 'Ordering' section on our website.

Text copyright: Dylan Trigg 2013

ISBN: 978 1 78279 077 8

A CIP catalogue record for this book is available from the British Library.

Design: Stuart Davies

Printed and bound by CPI Group (UK) Ltd, Croydon, CR0 4YY

We operate a distinctive and ethical publishing philosophy in all
areas of our business, from our global network of authors to
production and worldwide distribution.

CONTENTS

It must not be supposed that atoms of every sort can be linked in every variety of combination. If that were so, you would see monsters coming into being everywhere. Hybrid growths of man and beast would arise. Lofty branches would spread here and there from a living body. Limbs of land-beast and sea-beast would often be conjoined. Chimeras breathing flame from hideous jaws would be reared by nature throughout the all-generating earth.

Lucretius, *On the Nature of the Universe*.

Before Life

A vast, sepulchral universe of unbroken midnight gloom and perpetual arctic frigidity, through which will roll dark, cold suns with their hordes of dead, frozen planets, on which will lie the dust of those unhappy mortals who will have perished as their dominant stars faded from their skies. Such is the depressing picture of a future too remote for calculation.
H. P. Lovecraft, Clusters and Nebulae.

A planet in the solar system. Dwarfed by darkness, the planet emits a distress signal in the form of an evolutionary accident termed "life." On this green and blue orb, a slow terraformation of the alien landscape will begin. Deep ravines cut into the surface of the planet, a boundless ocean now separated by continents, on which cities and forests intertwine. Beings will colonise the minuscule unit of space in the cosmos, transforming the planet into a habitable world. From nowhere, further generations of living animals will come into existence. There, they will establish a base on the interstellar ark; both cultivating the land and fortifying themselves with built structures they will term "homes." Here, they will dwell with the assurance that the planet they have found themselves on is both their origin and their future.

An event will occur in the future that will bring about the planet's slow extinction. Ten thousand years will pass, and a new ice age will begin. In the arid deserts of the planet, glaciers will begin their slow, creeping advance. In time, the oceans will themselves become frozen landscapes, linking hitherto isolated countries. Cites that once housed millions of people will become deserted, and the lights that illuminated the planet will flicker

erratically in the darkness of night, before slowly but irretrievably being consigned to total blackness. Of the few who refuse to depart from the planet, they will remain as scavengers of a lost world. With the seasons colonized by the unrelenting cold, farming and all other modes of sustenance vanish. There, the fragments of a population that remain will establish a new territory in the ancient forests that have become their new homes.

Time will proceed, and the ice will withdraw. In its place, the planet's sun will undergo its own entropic decline, annihilating whatever animal life remains on the surface of the planet and forcing any residual life to seek exile in the depths of the oceans. As for the rest of the planet, much of it will be covered by dunes, interspersed with dried rocks and endless horizons of empty sand. Up above, the blue sky that shrouded the planet in times long gone will be filled with unrelenting thunderstorms and hailstorms. Over a longer expanse of time, the oceans that remain will evaporate, leaving immense basins of dried salt where the swelling of blue water once existed. The place from which life slowly emerged onto the surface of the planet will cease to be, finally dissolving the bonds between life and non-life, and thereby reducing all matter to an undulating terrain, in which everything and nothing exists. Everything that exists, has existed, and will exist no longer bears any trace of its presence.

* * *

For too long philosophy has laboured under the assumption that post-humanism, in all its variations, offers us the only escape route from a legacy of anthropomorphism. Part of this thinking is legitimate. In the vision of an uninhabitable world, overrun with ruins and feral vegetation, an entire landscape opens, full of the possibilities of another philosophy. After humanity, so the thought proceeds, the world will go on without us, thus reinforcing the fundamental contingency of our existence as a

particular species of life.

This tragic realization becomes the site of a new philosophy. Whereas the old philosophy found it impossible to envision the world in a non-sensuous and non-subjective way, indeed going so far as to align this non-subjective world with naïve realism, the new philosophy openly asserts the validity of realism and equally contests any form of antirealism.

Opposed to the post-Kantian tradition (and for that matter any philosophy that would emphasize the irreducible centrality of the subject), the new philosophy takes as its point of departure the world outside of the subject. Into the wilderness of thought, objects that hitherto seemed to constitute an innocuous background to our lives becomes enchanted with a weird aura. Indeed, the very term "weird" becomes the site of a critical reevaluation of existing norms, in which the gaze of human subjectivity loses its privileged place.

Against this horizon of speculation, the phenomenological tradition, once a beacon of integrity, has become emblematic of a failure in thought to think outside of the subject. Instead, the method purportedly reduces the world of things to an anthropomorphised world, enclosed at all times with an unbreakable alliance between subject and world, best exemplified in the Heideggerian phrase, *being-in-the-world*.

In the shadow, not only of phenomenology, but also linguistic idealism and post-structuralism, a call has been made to a post-human ontology, which delivers us from this obsolete legacy of thinking the world in terms of how it can be accessed for us, and us alone. Into this vision, the promise of a philosophy that replaces subjects with objects finds its inspiration in the image of a world without us. Aesthetically, the vision merely reinforces what the new philosophy knew all along: that human beings are not and never were at the centre of things. To be sure, humanity persists through this thinking, but only now is rendered ontologically equal to any other object, be it a carved table or the red rain

in Kerala. Thus, if humans and the world still exist in a relation with one another, then the relation is no more special than that between a forest and the night.

Today, this promise of a philosophy that replaces subjects with objects has long since folded back upon itself, becoming a distinctly human—alas, all too human—vision fixed at all times on the perennial question: *How will the Earth remember us?* A strange impasse intervenes. Despite its attempt to transcend a philosophy that binds the subject with the world, the new philosophy remains linked to a glorification of the world that persists long after humans have left the scene, both conceptually and empirically. What emerges is a philosophy at the end of the world, in which thinking gains its power by cultivating the ruins that outlive this end before then employing those ruins as ambassadors for a lost humanity.

Yet something else remains in this end. Beyond the ruins of a lost world, there is a persistence of matter that renders the philosophical apocalypse possible in the first place. If we were to invoke the Cartesian method of doubt to arrive at a foundational ground to account for this matter, then we might reformulate the cogito less in terms of an *I think* and more in terms of an *It lives*. What survives the end is a thing that should not be, an anonymous mass of materiality, the origins of which remain obscure. The thing is no less than the *body*.

* * *

This book sets out to do two things. One, to redefine phenomenology as a philosophical method of inquiry. Two, to demonstrate phenomenology's value by conducting an investigation into the horror of the body. The need to reinstate phenomenology's validity is twofold: On the one hand, the renewal is set against the backdrop of phenomenology itself, as it would traditionally be conceived and practised by its exponents through the

twentieth century, and even beyond. In this context, phenomenology marks a mode of inquiry concerned with a particular type of human experience, characterised by a sense of unity and coherence. From this perspective, phenomenology is specifically human, not only in its epistemological limitations, but also in its ethical tendencies.

On the other hand, the need to redefine phenomenology takes as its point of departure recent developments in continental philosophy, not least the challenges put forward by Quentin Meillassoux. In this reading of phenomenology, the method is reduced to a concern with access to the phenomenal realm, in which human subjectivity is placed at the centre, and where a thinking outside of the subject is inconceivable. While this book engages with the ideas of Meillassoux, the model of phenomenology presented does not seek to define itself in opposition to this background. At stake is not the question of becoming complicit with Meillassoux, but of recognising the value of entering into a dialogue with certain strands of his thinking.

In contrast to this background, the phenomenology outlined in this book is attuned to both human and nonhuman entities. In this work, human experience is a necessary point of departure for philosophical inquiry. But it is only that—a departure. Beyond humanity, another phenomenology persists. Far from being the vehicle of a solely human voice, we will show that phenomenology can attend to a realm outside of humanity. Indeed, in this book we seek to defend a model of phenomenology that is not only capable of speaking on behalf of nonhuman realms, but is especially suited to this study of foreign entities. We will term phenomenology's specific mode of accounting for the nonhuman realm, the *unhuman*. Why this terminology? The reasons are twofold.

First, the inclusion of the "un" in unhuman aligns the concept with the notion of the uncanny. Our account of the unhuman accents the gesture of repression that is synonymous with the

uncanny, especially in its Freudian guise. With the unhuman, something comes back to haunt the human without it being fully integrated into humanity. In this respect, the unhuman is closely tied up with notions of alienation, anonymity, and the unconscious (and to this extent, is also registered by the equivalent but more cumbersome term, *xenophenomenology*).

Second, the distinction of the unhuman is that it does not negate humanity, even though in experiential terms it may be felt as a force of opposition. As we will see, it is precisely through the inclusion of the human that the nonhuman element becomes visible. This does not mean falling back into anthropomorphism. Rather, it means letting the unhumanity of the human speak for itself.

If phenomenology finds itself in an apparent impasse, then it is precisely because its rebirth is not only needed but also especially timely. In what follows, the plan is to reinforce the vitality and dynamism of the method, with a reach that extends beyond the human body and crawls into another body altogether. The task, such as it presents itself, is to excavate aspects of phenomenology that can help us chart the emergence of a future phenomenology from within the history of the tradition.

An unhuman phenomenology, then, is a phenomenology that runs against the notion that description is a guarantor of truth, and thus strikes a discord with traditional phenomenology. In this way, unhuman phenomenology is a genuine alien phenomenology in that it is concerned with the limits of alterity rather than simply replacing subjects with objects. The germs of this redefined phenomenology are already evident in the lesser known works of Husserl, Levinas, and Merleau-Ponty, all of whom are central and recurring figures in this work. Many of their ideas concerning anonymity, archaeology, and alterity are instrumental in guiding an unhuman phenomenology to the shores.

* * *

To situate these ideas in context will require that we turn to the affective experience of phenomenology becoming its other. To this end, our phenomenology focuses on the materiality of the body before treating that materiality within the framework of horror. What is the body? On the one hand, it is the site of all that is irreducibly human—the bearer of value and ethics, and the means by which our being-in-the-world is possible. More than a homogenous mass that enables us to get from one point in the world to another geometrically, it is through the body that the world gains meaning. On the other hand, the body is a work of physiology that can be examined in objective terms. Inside the body, a set of organs can be found, without which our existence as subjects would be threatened.

In terms of our idea of what it is to be a self, it is only comparatively recently that the body has assumed importance. Indeed, historically, our conception of what it is to be human has tended to focus on the singularity of the mind. Thus, in the manner of British empiricism and Cartesian rationalism, the body becomes contingent while the mind retains its sovereignty. For John Locke, this contingency extends to the parts of the body themselves:

> Cut off a hand, and thereby separate it from that consciousness he had of its heat, cold, and other affections, and it is then no longer a part of that which is himself, any more than the remotest part of matter (Locke 1993, 182).

Pace Locke, for the most part our attachment to the body tends to be more than a mere formality. Theoretically, this attachment has been legitimised through phenomenology and more recently cognitive science, both of which posit the primacy of the body. The present work is complicit with the view that body is primary

in the constitution of self. But in distinction to the classical phenomenological view that would characterise the body as the site of unity and coherence here, the body is anterior to personal history, and at all times in a divisive relation to the subject.

Part of the problem inherent in traditional phenomenology is that it has become too comfortable with the idea that the bodily subject under investigation is a distinctly human body. The human body, as it figures in phenomenology, tends to be characterised by a sense of ownership and self-identity. It is a body that carries with it a rich multiplicity of moods, each of which anchors us to the world. While there is no doubt that such a body exists — it is reasonable to assume each of us has a relation to one — this body is not exhaustive, nor does it account for the material conditions under which life emerges. A bodily subject (in phenomenological terms) is not necessarily a *human* subject. Another body needs to be accounted for in phenomenology. A creature that invades and encroaches upon the humanity of this thing we term "the body," while at the same time retaining the centrality of the human body as its native host.

By contrast, we would like to propose an unethical body, anterior to personal identity and prior to cultural assimilation. And it is important to note that how a living body finds itself attached to a life is wholly contingent. The particular configuration of the human body is not an end point in history, but part of a mutating process, which may or may not transform into another shape. The body to be posited in this book is not only anterior to humanity but in some sense opposed to human existence, at least insofar as it destabilises the experience of being a subject by establishing an unassimilated depth within the heart of familiar existence.

It is for this reason that the horror of which the title of this book speaks is fundamentally a *body horror*. The affective response of horror — far from an aestheticising of alien existence — is the necessary symptom of experiencing oneself as

other. The point being that the involvement of horror in this phenomenology is not for the sake merely of countering a tendency in phenomenology to exhibit the human within the scope of light and unity. Rather, horror concerns as much the structure of the human becoming unhuman as it does the thematic experience of this transformation. Indeed, without horror, the framework of an unhuman phenomenology would resist conceptualization altogether.

This horror takes its cues from both a conceptual horror—a horror inherent in the deformation of phenomenology itself—as well in the cinematic and literary articulations of such ideas. In the films of John Carpenter and David Cronenberg, and in the writings of H. P. Lovecraft, we gain a sense of the body as the site of another life. If it is a life that manifests in the contours of the human body, this does not mean that such a life is reducible to humanity. Rather, the horror of the body marks both the betrayal of an anthropocentric phenomenology, and (for precisely this reason) its renewal. In this way, it is only because we begin with the centrality of the body as a pregiven theme that its eventual figuration as uncanny, other, and resistant to integration becomes possible.

* * *

In what follows, we will explore a phenomenology of body horror in four ways, marked by each chapter. Each chapter forms a whole, which loosely plots the origins of the body. Accordingly, in the first chapter, the relation between the Earth and the body forms the main concern. The chapter takes as its point of departure recent findings in astrobiology concerning ancient Martian meteorites discovered in the Antarctic. These discoveries are situated in the context of a late fragment from Husserl known as "The Earth Does Not Move," concerning the Earth as understood phenomenologically. For Husserl, the Earth is not

just an empirical object in space but, more primordially, a foundation upon which the possibility of bodily subjectivity is dependent. In order to address the limits of such a phenomenology, we will consider some recent findings in astrobiology, which are suggestive of the possibility that life on Earth may have had its origins elsewhere in the solar system. Even at a hypothetical level, what these findings suggest is that our understanding of the human-Earth relation needs to accommodate the notion that the origin of life is not grounded in a transcendental structure, as Husserl has it, but instead involves the notion of life as, in the words of Merleau-Ponty, a "metamorphosis" rather than "beginning from zero" (Merleau-Ponty 2003, 268). To flesh this claim out, reference is made to *Quatermass and the Pit* directed by Roy Ward Baker (1967). This film is exemplary in articulating the anterior origins of the human body at both a conceptual and imaginary level.

In the second chapter, the theme of the alien Earth is interwoven with the origin of the body itself. To chart the emergence of the body, we turn to Levinas. Emmanuel Levinas is often thought of as a philosopher of ethics, above all else. Indeed, his notions of the face, the Other, and alterity have all earned him a distinguished place in the history of phenomenology as a fundamental thinker of ethics as a first philosophy. But what has been overlooked in this attention on ethics is the early work of Levinas, which reveals him less as a philosopher of the Other and more as a philosopher of elemental and anonymous being. Two claims are made: First, Levinas's idea of the *"il y a"* (the *there is*) offers us a way of rethinking the relation between the body and the world. This idea can be approached by phrasing Levinas as a materialist. Second, the experience of horror, on which Levinas will place great emphasis, provides us with a phenomenology at the threshold of experience. As we will see, it is precisely through what Levinas terms "the horror of the night," that phenomenology begins to exceed its methodological constraints in accounting for a plane of

elemental existence beyond experience. Through this, a phenome-
nological realism can be developed, with the materiality of the
body, above all, coming to surface as an existence that both enables
and exceeds subjectivity. These ontological notions are played out
in the work of Andrei Tarkovsky, especially his early film, *Solaris*
(1972). It is in this film that we can witness the Levinasian account
of the body as constitutive of subjectivity but at the same time a
betrayer of subjectivity.

If the first part of the book focuses on the emergence of life on
Earth, then the second part focuses on the specific life that
inheres in the human body. Thus, the aim of the third chapter is
to give an account of the prehistory specific to the human body.
This is achieved by pairing Merleau-Ponty and Lovecraft in
dialogue with one another, specifically Lovecraft's seminal story,
The Shadow Out of Time. With recourse to Merleau-Ponty, we will
see that Lovecraft's story shows us two things about alien subjec-
tivity: First, constitutionally, the human subject can be seen as
"sharing" its bodily experience with a prehistoric subject. In
Lovecraft's tale, the horror central to the narrative centres on the
struggle between the body as possessor of the subject and the
body as possessed by the subject. Second, temporally, this prehis-
toric constitution sets in place a body out of joint. This focus on
the temporality of the alien subject throws into doubt traditional
notions of personal identity as relying on the continuity of
personal memory and instead raises the spectre of phylogenetic
memory. Such themes are then analysed in their cinematic
appearance in the works of David Cronenberg and John
Carpenter.

The final chapter confronts a series of critiques posited in
contemporary continental philosophy concerning whether
phenomenology can account for non-human things. In
particular, this issue is taken up through introducing
Meillassoux's notions of "arche fossils" and "ancestrality" into
the discussion. Meillassoux's ideas are important because they

problematize access to things "anterior even to the emergence of life." In his view, correlationism is only able to derive knowledge of the past from the standpoint of the present, thus rendering the phenomenologist (by implication) the guarantor of knowledge "for us." By engaging with Meillassoux's critique of phenomenology, a counter-argument is formulated based on Merleau-Ponty's late ontology of the flesh. What Merleau-Ponty shows us is that our value-laden narcissistic reflection on our place in the universe is offset by the collapse of conceptual thought. Through this collapse, the elemental foundation of what he terms "the flesh" is proven to be ontologically prior to correlationism in the first instance. In turn, we will employ Merleau-Ponty's notion of the flesh to stage a debate with Meillassoux's idea of "arche fossils."

If these concepts are resistant to experience, then they can nevertheless be approached through an indirect route; namely, that of the cinematic image. Accordingly, in the conclusion of this book, we turn to John Carpenter's seminal film, *The Thing* (1982). Carpenter's film—and his vision more broadly—is essential in allowing us to formulate the central thesis of the book, namely: *the horror of the cosmos is essentially the horror of the body*. Our point of departure for examining Carpenter's film is that the abject creature in the film is an expression of the origin of life itself. This is evident in that the body can be seen as being constituted not only in structural terms by an alien subjectivity, but in thematic terms by an anonymous teleology, the implication being that the origin of the universe is both constitutive of humanity and also *against humanity*.

Chapter 1

From Beyond

Primal myth and modern delusion joined in their assumption that mankind is only one—perhaps the least—of the highly evolved and dominant races of this planet's long and largely unknown career. Things of inconceivable shape, they implied, had reared towers to the sky and delved into every secret of Nature before the first amphibian forebear of man had crawled out of the hot sea three hundred million years ago. Some had come down from the stars; a few were as old as the cosmos itself; others had arisen swiftly from terrene germs as far behind the first germs of our life-cycle as those germs are behind ourselves. Spans of thousands of millions of years, and linkages with other galaxies and universes, were freely spoken of. Indeed, there was no such thing as time in its humanly accepted sense.

H. P. Lovecraft, *The Shadow Out of Time*

North-west of Coombs Hill and just beyond the Mawson Glacier, a group of hills of unprecedented importance are to be found in the wilderness of Antarctica. Named after Professor R.S. Allan of the University of Canterbury, New Zealand, Antarctica's Allan Hills are the site of countless meteorites buried in and around the Transantarctic Mountains. Of these meteorites, one has assumed a particular significance. On December 27, 1984, a team of US meteorite hunters from the ANSMET (Antarctic Search for Meteorites) project chanced upon what looked like another Martian meteorite devoid of life. Lying buried in the frozen wastelands for 13,000 years, the meteorite would be classified as ALH84001.

This was not the first Martian meteorite to be found on the

surface of Earth. Already in 1865, the Shergottite family of meteorites fell in Shergotty, India. At 9am on the 25th August of that year. Some 46 years later, on 28th June 1911, another meteorite shower fell from deep space, this time landing in the village of El Nnakhla El Baharia, east of Alexandria, Egypt. Here, too, the meteorite arrived at 9am. These cosmic fragments were heavier than the Shergottites, and during the re-entry a chunk of Martian rock was reported to have landed on the spot where a farmer's dog was resting, vaporising the creature instantly and leaving a green fragment in the dog's place.

Although it is impossible to establish a strict chronology of the events leading to the arrival of the Nnakhla meteorite in the village of Nnakhla El Baharia at 9am on June 28th 1911, scientists have established the following: an asteroid would have collided with the surface of Mars some 11.5 million years ago, in the process blasting chunks of solidified magma off the surface of the planet into space. Escaping the gravitational field of Mars, the Nnakhla artefact would orbit the sun and collide with other rocks.

Meanwhile, back on Earth, prehistoric ancestors of the Nnakhla dog were in the process of evolving, while *Homo sapiens* themselves had yet to distinguish themselves from gorillas. And so the Nnakhla meteorite would wait silently for millions of years before being carried into the atmosphere of Earth, our planet. There it would fall to the surface of the Earth, leaving a column of white smoke in the morning sky before landing on the spot where the farmer's dog would rise from the night.

Like the Chassignite meteorites found in Chassigny, France on 3rd October, 1815 (this time at 8am), the Shergottite and Nnakhla relics all had a crystallization age of 1.3 billion years. Through a process of deductive elimination, the artefacts were found to be of Martian origin. Following the 1976 NASA Viking missions, trapped gases were found in Shergottite that were also found on Mars by the Viking Landers, thus confirming the interplanetary

relation between Earth and Mars.

The so-called SNC group of Martian meteorites (after the Shergottite, Nnakhla, Chassignites group) has an anomaly, and the anomaly is ALH84001. Although similar in appearance and mineralogy to non-Martian meteorites, ALH84001 has some significant differences, amongst which is its age. Whereas the rest of the SNC group of meteorites dates to around 1.3 billion years ago, ALH84001's origins are 4.5 billion years old, making it one of the oldest bits of the solar system. Moreover, whereas ALH84001 is similar to basalts and lherzolites, it cannot be classified as this type of rock. There is another substantial difference between ALH84001 and the other SNC meteorites: within its grey core, fossilized organisms attesting to the existence of extraterrestrial life on ancient Mars have been found.

The grounds for asserting the claim that ALH84001 bears traces of Martian life are the presence of polycyclic aromatic hydrocarbons in its core. Polycyclic aromatic hydrocarbons are complex organic compounds, which are notable because they point to an organic origin. In these compounds, the atmosphere of Mars has been preserved, from which scientists have been able to detect latent traces of water, an element that is normally thought to be essential to the production of life.

Led by scientist David McKay and his team at the NASA Johnson Space Center, the dissection of ALH84001 revealed a biomorphic worm-like organism, which closely resembles nanobacteria. While it is possible that this figuration of life may be influenced in part by any number of contingent factors—not least terrestrial contamination—the evidence to support McKay's claim that ALH84001 reveals evidence of extraterrestrial life has gained momentum since the team made the announcement in 1996.

Already in 1996, President Clinton was willing to countenance the possibility of Martian life in light of McKay's research, remarking from The South Lawn of the White House on that

fateful August day:

> Today, rock 84001 speaks to us across all those billions of years
> and millions of miles. It speaks of the possibility of life… We
> will continue to listen closely to what it has to say as we
> continue the search for answers and for knowledge that is as
> old as humanity itself but essential to our people's future.[1]

Since then, McKay's team have amassed further evidence for
exobiological phenomena in ALH84001, placing it in the
Noachian epoch of Mars' geological history, during which time
Mars was covered in vast oceans, thus generating the necessary
conditions for life.

Such discoveries gain a striking quality when situated in the
context of traditional accounts of the origins of life. Until recently,
for example, the study of biopoesis has centred on the idea that
organic life may have been sparked by electrical lightning or
otherwise formed in the sea, thus producing elementary lifeforms
such as the prokaryotes. A life enters the phenomenal world.
From a broadly vitalist perspective, we register it as such both in
terms of its propensity to move and to metabolize matter,
gestures that resist entropy, and thus indicate a fundamental will
to live. The earliest form of life on Earth occurred 3.5 billion years
ago, 1 billion years after the existence of ALH84001. At that point,
the Earth was devoid of predators, yet evolution was already in
process. The tacit question in the discovery of ALH84001
concerns whether or not the prehistory of Mars assumes a
material legacy in life on Earth, and if so whether that life is
indeed different from native Martian life.

The Ghosts of Mars

The idea that life may have begun elsewhere in the universe—the
theory of panspermia (Greek for "seeds everywhere")—is not a

new one. In fact, its origins can be traced back to Anaxagoras and before him to Egyptian mythology. It is from Egypt that Anaxagoras' theory of the origins of life evolves. The theory posits the existence of primordial *sperma* (seeds), which are dispersed throughout the universe and create Earth—in fact, many Earths—and all living things inhabiting these planets. These seeds can be viewed as primordial or incipient nodes of potentiality, a spark that is both real and metaphysical. In Anaxagoras' fragments, the seeds are presented as producers of things, including life itself, which, by dint of pure contingency, found the stable conditions for growth here on Earth.

For Anaxagoras, the seeds of the cosmos are held together by the unity of a mind, which constitutes all things and yet remains irreducible to those things. This cosmic idealism serves to arrange matter in a coherent and unified form, which, according to Diogenes Laertius, was hitherto in a state of disarray (Barnes 1987, 236). Diogenes Laertius goes on to provide a fuller account of a key event in Anaxagoras' thought, writing as follows: "They say that he predicted the fall of the meteorite which occurred at Aegospotami—he said that it would fall from the sun... When he was going to Olympia he sat down under a cloak as though it were going to rain—and it did" (237). Anaxagoras' confrontation with the mass of materiality from outer space confirmed his sense that particles from different points in the cosmos have the ability to travel far without losing their power to germinate life.

As we now know, the existence of microorganisms able to survive extreme environments, persisting through both time and space, is an empirical reality. Extremophiles, as they have been termed, are organisms able to survive in the absence of conditions that are conducive to what we think of as life. In extremities of heat, coldness, darkness, dryness, depth, and radiation, innumerable quantities of microbes persist through unimaginable conditions.

In the ostensibly lifeless caves of the Atacama Desert—a

region often compared to the landscapes of both the Earth's moon and Mars—we know that organisms such as the Dunaliella algae are able to survive in the near absence of water. Likewise, Aquifex—an extremophile found in the hot springs of Yellowstone National Park, California—not only survives but actually thrives in temperatures of up to 205 degrees Fahrenheit (95 degrees Celsius).

And then there is the cold. A recent discovery in the subglacial Lake Whillans, Antarctica by the WISSARD team of scientists (Whillans Ice Stream Subglacial Access Research Drilling) led to evidence of life buried beneath the surface. How the microbes were able to sustain life in such extreme conditions is unclear, though Chris McKay—a well-known planetary scientist—speculates that the organisms may be using a "local energy source."[2]

The existence of extremophiles reinforces the colossal scale of life, both known and unknown, on Earth alone. Such discoveries not only transform our concept of life, but also the very places in which these strange lifeforms persist. Thus beneath the clear waters of the Connecticut River, the prehistoric remains of an Ice Age lake known as Lake Hitchcock can be found. Formed 15,000 years ago, in the clay surface that exists today, are an army of (hitherto unknown) red worm-like larvae. In other areas of the prehistoric river, deeper than that in which the chironomid larvae dwell, strange organic matter resembling enormous sponges remains embedded in the sediment.

The discovery of extremophiles dwelling in the depths of the Earth and able to survive environmental extremes reinforces the possibility that artefacts such as ALH84001 have the potential to house the fossilised remains of Martian microbes. The bacterium found in ALH84001 is not only amongst the hardest matter in existence, but can also enter a state of dormancy when faced with extreme conditions. Likewise, when the environmental conditions resume a state of stability, the bacterium is reanimated.

* * *

Such thoughts concerning reanimated Martian life may be speculative, but they are nevertheless important (both conceptually and empirically) for tracing the origins of the life on Earth, especially as it figures in the materiality of the body. Epistemologically, the discovery of life on another planet is problematic—if not presently impossible—in that any understanding of alien life is already predicated on a conception of life that has its roots in the history of the Earth: that is, a concept of life as held by a subject whose history is tied up with life as it is understood from an earthly perspective. For example, while a similar ecological system may be in place for an analysis of Martian life, these accounts of extra-terrestrial life serve only to extend current ideas of life rather than departing from those ideas. The questions of what life *is* and where it can be found, therefore, risk falling into a circularity, in which both questions simply reinstate what we already know about the structure of life. Can thinking breach the limits of its own history in order to contend with the alterity of the alien? Or will we remain locked in a narcissistic vision of the cosmos, in which the alien is nothing more than a doppelgänger of our own memories?

To phrase these thoughts in the language of psychoanalysis, we might ask: is ALH84001 an object to be understood in astrobiological terms or is it a marker of a different kind, one that reveals the traces of our own unconsciousness long before ALH84001 was "discovered" in the Antarctica?

On a symbolical level, the meteorite is a key to the rediscovery of a lost origin, a fragmented part of a cosmic jigsaw puzzle that will enable human beings to ascertain the origin of life on Earth. The discovery takes place against a background of Pascalian anxiety. Over the blackened abyss, space becomes the mirror of an infinite terror. As Pascal turns to the darkness in which the Earth hangs suspended, a repelling horror is felt in the

flesh. The void is silent, and the finitude of a human being's call remains unanswered. Into this cosmic anxiety, the void does not speak, except as a form of resistance, an anti-speech. The lack of dialogue, this break in relations, becomes a problem. The cosmos is transformed into a site of oppression, breaking the human's need to be heard, and thereby forcing a confrontation with the limits of narcissism. Out there, in the silence without a witness, there is nothing. Nothing, that is, except for your *own voice*.

In the face of this silence, unmanned robots are sent to investigate the scene of anxiety. There, automatons search the deepest recesses of the known universe in pursuit of something other than the humans that put the machines there in first place. Very little is discovered, save for photographic imagery of the Earth taken from other planets. But then, quite suddenly, ALH84001 is found back on Earth. The object summons hope that life exceeds the margins of this planet. From the remains of a fossilized worm, evidence of a world beyond our own flourishes.

But what leads to this discovery, science or the unconscious? Put another way: to what extent does ALH84001 mark a reality anterior to human experience? With Pascal, there is nausea in the silence of the cosmos—an endless night of anxiety and insomnia, in which something opposed to the subject remains as that: a *remainder*. And then there is Mars, the Promethean origin of life on Earth. The intervention of ALH84001 allows Mars to speak to us. The red planet has been terraformed, not through machines but through its symbolic appropriation as a planet that speaks to the Earth by echoing the materiality of its voice back to our planet.

* * *

A phenomenological inquiry into an object such as ALH84001 would need to meditate between imagination and reason, between consciousness and unconsciousness. The scientific

validity of ALH84001 is less important than its very existence as an artefact of thought, which raises the question to what extent our understanding of humanity as the possessor of a corporeal history tied to the Earth is related to the figure of the alien. In fact, it is precisely through a hyperbolic (or in a Herzogian idiom, *ecstatic*) rather than factual reading of the meteorite that we begin to gain a clearer understanding of its implications (Herzog 2002).[3]

The philosophical framework for posing such questions is established in the late works of Husserl and Merleau-Ponty. By exploring the speculative phenomenologies offered by these philosophers, we will we be in a position to consider how such ideas are played out in terms of a limit in phenomenology—a limit registered in the concept of horror.

Another Earth

The existence of ALH84001 presents a series of challenges to our idea of what it is to be a human tied to the materiality of the Earth. For the sake of narrowing down our investigation, let us consider one question in particular: to what extent does the human body owe its origins to the history of the Earth? Such a question is not novel. In fact, we can find Husserl circling around this thought in a fragment from 1934 known as "The Earth Does Not Move" (Merleau-Ponty 2002). Husserl begins this fragment by stating the importance of the topic, going so far as to preface his notes with the claim that the "following pages are... foundational for a phenomenological doctrine of the origin of spatiality, corporeality, Nature in the sense of the natural sciences, and therefore for a transcendental theory of natural scientific knowledge" (117). Even if the fragment is a preparatory study, then the inclusion of spatiality, corporeality, and the scientific knowledge of Nature are tied together in his specifically phenomenological account of the Earth as a foundation.

His point of departure for establishing this foundation is the surrounding world as an infinite space; that is, a space that "is not completely conceived, represented, but that is already implicitly formed" (117). This occurs on a localised level in terms of the borders between city and countryside, between individual countries, between continents, and then of the Earth itself. On this initial phenomenological reduction, the Earth is given as a unity taken from the standpoint of the individual subject, who unifies "the experiential field… in a continuous and combined experience" (118).

This thinking takes places against the backdrop of a scientific conception of space. From a "modern" (Copernican) perspective, the Earth is a discrete planet set against the backdrop of "infinite space" (118). More than this, it is a body, though a special kind of body. Not one that can be approached in its wholeness—Husserl is writing, of course, before the famous "Blue Marble" photo taken in 1972 by the crew of Apollo 17—but a body that is the "experiential ground of all bodies" (118). Our everyday relationship to the Earth, as Husserl presents it, is not a bifurcated relationship, whereby the Earth is simply one planet among many. Nor is it a fragment of materiality on which other smaller fragments exist. Rather, the Earth is a ground (*Erdboden*) and in this respect, a constitutive structure in our experience of spatiality.

Seen in this way, Husserl's Earth is, before anything else, a given of experience. Considered in this pre-thematic manner, the Earth assumes its importance as an origin of the very structure and possibility of bodily existence, without which movement and rest would not be possible. The task, such as it is for Husserl, is to return to the Earth itself—the Earth that underpins all subsequent scientific reductions of the same planet to a material entity and in this respect, to reinforce its validity as a relation.

With this background, Husserl is now in a position to consider the relationship between the Earth as a singular planet and the

human bodies that inhabit it. Central to this phenomenology is the question of whether or not there can be another Earth. Such an issue draws to light the role of the Earth as constitutive of subjectivity. Can another Earth—be it Mars or the moons of Jupiter—assume the constitutive role the present Earth does now, and if so what are the implications for corporeality as we know it?

As primordially constituted by the Earth, our sense of being endowed with earthly bodies in an earthly space is beyond transcendence. The Earth, in its geological and temporal depth, constitutes the body in such a way that whatever secrets the Earth conceals are also concealed within myself. As Husserl has it, our own history as belonging to a particular homeland, is situated within the homeworld of the Earth, to which we each belong and can never escape without already defining ourselves as having left the Earth, as he writes: "All developments, all relative histories have to that extent a single primordial history of which they are episodes" (127).

In the speculation of another Earth, therefore, Husserl's account of the history of the body ties us to an origin that is beyond the subject. Of other planets, Husserl is prepared to suggest that the "interpretation of the world in human history, in the history of the species, within the evolution of the individual and people, [is] an obviously accidental event on the earth which might just as well have occurred on Venus or Mars" (129-130). In turn, other planets would simply assume the constitutive role that the Earth does at present.

Likewise, if I am an astronaut who decides to settle on Mars as my "primordial home," then at no point does my colonization and subsequent approbation of Mars as my homeland strip me of my "terrestrial humanity" (13). As he writes decisively: "There is only one humanity and one earth—all the fragments which are or have been separated from it belong to it" (130). Husserl's Earth, such as it is, is fundamentally sculpted by its human

constitution, just as humanity is fundamentally sculpted by its earthliness. This does not discount the "modern" view of the Earth as a body, but instead presents us with two sides of the same face: a transcendental Earth and an objective Earth.

Toward the end of the fragment, Husserl makes a curious intervention in this line of thought, yet one that will be central for our own phenomenology. Developing a series of objections against the primordiality of the Earth, he considers the prospect "that entropy will put an end to all life on earth, or that celestial bodies will crash into the earth, etc." (131). The thought being that the phenomenological validity of the Earth as ground would lose its legitimacy when reduced to the status of a thing.

The problem is important because it pushes to the surface the question of the extent to which the Earth and the body are co-constituted. Not only this, but it also thematizes the question of how the Earth—if we take the Earth not only as an *Urheimat* (primal home) but also an *Urhistorie* (primal history)—can be considered as both phenomenological and non-phenomeno-logical in structure.

We already know that Husserl formulates the Earth as an original ground, which is beyond transcendence. In the face of a destroyed Earth devoid of its humanity, Husserl only reinstates the validity of transcendental phenomenology by drawing an analogy between a fragmented Earth and the process of dying. In the case of the death of others, a unity is retained inasmuch as "recollection permeates life—I still live," and thanks to the power of reiteration I am able to retain the presence of the "We" (131). With this, Husserl is setting up his counter-response to the notion of an Earth that is in the first instance a mass of material reality, and that alone.

Husserl here turns to a transcendental argument for the existence of the "constituted world," asking directly "What sense could the collapsing masses in space... have, if the constituting life were eliminated?" (131). It is the constituting ego as a

transcendental entity that "precedes all actual and possible beings, and anything existent whether in a real or irreal sense" (131). For this reason, any such reference to the finitude of the Earth's collapse hinges at all times on a prior positing of the transcendental structure of the constituting ego, stating that "What belongs to constitution is, and is alone, the absolute and ultimate necessity" (131).

As we see, then, Husserl presents us with an account of the Earth as a foundation. It is a foundation in at least two respects. In the first respect, the Earth is a foundation in that it renders movement and rest possible by establishing a relational axis between the body and the Earth as ground. In the second respect, it is a foundation in that it constitutes the specificity of the body as having an origin. So long as there are human bodies, then those bodies will remain tied to the Earth, which can never truly be left behind, despite the prospect of terraforming another Earth than our own.

Alien Subjectivity

Husserl's account of the relation between the Earth and the body is consistent with a transcendental phenomenology, which privileges the irreducibility of the subjective ego. Because of this, it suffers from a series of limitations. Above all, the Earth, as it is understood in Husserl, is at all times a humanised Earth, which gains its structure thanks to a relationship with the body. And the same is true in reverse. At no point does a Husserlian phenomenology seem capable of conceiving the body as a real entity; that is, having a conceptual reality independent of the Earth.

Indeed, as we have seen, even when faced with another Earth, the difference of the host planet is simply appropriated as an extension of the Earth, with the body acting at all times as the negotiating device. Thus, by the end of his reflections, Husserl

remains committed to the singularity of the relation between Earth and the human body. In his view, we remain insulated in a kind of cosmic correlation, against which the possibility of truly departing from the soil is undermined at all times by the primitive origin of the Earth as a human realm.

How can we broach this relation between the Earth and the body? How, that is, can we counter the tendency to conflate the ethical and the epistemic, by rendering the Earth the foundation of both who we are and what we can know? It is precisely through taking seriously an origin that is anterior to experience rather than insulated to experience that a phenomenology of the alien can be rendered clear. Methodologically, we proceed by ontologically amplifying—to paraphrase Bachelard—the speculative phenomenology that underlies our relation to artefacts such as ALH84001.

ALH84001 presents us with the prospect of an origin that is anterior to subjectivity but at the same time constitutive of subjectivity. The origin is anterior to subjectivity insofar as it resists being integrated into the subject both spatially and temporally. Simultaneously, the origin is not consigned to a mythical past, but is instead implicated in the very materiality of the human being. This double bind is a paradox. On the one hand, in the flesh of our bodies, we find a materiality that leads us toward an alien existence. At the same time, this other world remains accessible in that it is given to us precisely as human subjects.

If the notion of an anterior origin marks a paradox in our understanding of human subjectivity, then it is perhaps only because the view of Husserlian phenomenology is still retained. In order to disrupt this view, another phenomenology will be necessary. Such a phenomenology will require us to discard the commitment to a transcendental relation between the Earth and the body, and instead view the body as a fragment of materiality that is both human and non-human concurrently. To achieve this, the notion of an alien subjectivity can be developed with recourse

to the late writings of Merleau-Ponty.

* * *

The human subject finds itself in a world. There, it recognises itself as having a history that predates its own birth. Beyond the world, another life takes place, one that precedes the subject while also conferring a responsibility upon the subject's existence. In time, the subject incorporates fragments of a history into the formulation of a self. The history is transmitted in time through the practice of cultural traditions and on a microcosmic level, through the evidence amassed in objects such as photographs and letters. Prior to this time, a more fundamental origin exists, which the subject can only speak of abstractly. Lacking a personal relation with this timescale, the subject cultivates a relationship to the deep past through scientific inquiry rather than direct experience.

And then the subject discovers something in the past that betrays this sense of belonging. It is an inscription from another time, one that ruptures the unity of the self in the present, without ever being fully present or integrated into the subject. This anterior origin marks a point of dissonance for the subject, an unknowable mass of materiality that becomes the site of a parallel history.

Merleau-Ponty approaches this other past from the perspective of the animal, and it is through the human-animal relation that we can approximate an understanding of the human-alien relation. Merleau-Ponty begins this discussion of the origin of the of the subject in terms of a "metamorphosis" rather than "beginning from zero" (Merleau-Ponty 2003, 268). In contrast to the idea that life evolves as a gradual process of cephalisation, thus departing from the realm of nature, Merleau-Ponty instead advances the claim that the body is "reflection in figural form" (268). Put another way, it is not the case that a

human being begins at one point in the deep past and then proceeds to sublimate the rational unfolding of a corporeal history. Rather, that same history co-exists alongside the subject in the present, forming a double that both mirrors and distorts the emergence of human existence.

For this reason, when Merleau-Ponty comes to speak of the human-animal relation, he does so in terms of a "lateral" relation "that does not abolish kinship" (268). We are faced with a kinship that invites the possibility of the animal and human living not merely alongside each other, but also *within* each other. In each case, what we find is a development of life that is predicated on ontological continuity between different lifeforms, as he has it, "before being reason, humanity is another corporeity" (269).

Moreover, the kinship, he goes on to say, is "strange," because in it, we confront the visibility of the invisible: that is, the fossilised remains of a life that is beyond experience, but nevertheless constitutive of life. Just as the animal pre-empts the human, so the human invokes the animal, as he says: "Animality and human being are given only together, within a whole of Being that would have been visible ahead of time in the first animal had there been someone to read it" (271).

Merleau-Ponty is concerned with the particular figuration of human life. To what extent is this articulation of life a specifically human one? From the perspective of a phenomenology that situates itself beyond the Husserlian level and is instead concerned with the prehuman sphere, prior to emergence of the ego, the distinction of life loses its clarity. Merleau-Ponty poses a critical question: "Life and nonlife are different only as chemistry of mass and individual chemistry: Are viruses living or nonliving beings?" (269). The question is in direct contradistinction to a phenomenology purportedly concerned with human experience, and that alone. From the perspective of a human subject, a virus or a disease enters the body and is experienced as a form of anti-life. It is experienced as something that reduces life to a paralysed

state, draining the body at all times of the resources in depends in order to advance itself in the world. But how does the virus perceive us, to paraphrase David Cronenberg? The very reversibility of these perspectives confuses the boundaries between life and nonlife, masking the phenomena with both dimensions at once.

Merleau-Ponty terms this converge of different lifeforms an *Ineinander* or intertwining (271). By it, he draws a "strange kinship" between animal and human into the course of evolution itself, from which "other corporeities" are also drawn (271). This constellation of divergent lifeforms inhabiting the same body is both spatial and temporal. The "metamorphosis" that he speaks of is one that both unfolds in time while also folding back on its own materiality. Thus, Merleau-Ponty will speak of a "rigorous simultaneity" between bodies, and thus to mark a "natal past," which is at the same time the site of a "phylogenetic" history.

The prehistory of the subject is also a prehistory of the subject's alterity—an alien region, in which both the deep future and the deeper past collectively dwell. This account of the human-animal intertwining does not present us with an alliance, which affords the human subject an opportunity to narcissistically reflect upon his own image projected in that of the animal. Rather, Merleau-Ponty shows us a genuine alterity that lurks within humanity, and equally "strange anticipations or caricatures of the human in the animal" (214). This gaze into the depths of a prehistory reveals a time prior to the split between animal and human. If the primordial vision is located in the abysses of time, then it is nevertheless one that is preserved in the articulation of the body, which, as we will see in the chapters to follow, retains the strange kinship binding the human with its nonhuman other.

Merleau-Ponty's philosophy of nature is thus a phenomenology of the subject as alien. In each case, we are faced with a subjectivity that is never integrated, but instead marks an excess,

something from beyond time that resists the level of descriptive experience. The subject becomes the site of another agency, one that resists knowledge, and thus marks a fissure that is not contained within the subject but is instead dispersed throughout the world. In this vision, phenomenology reaches a limit, and therefore must now be understood as an indirect ontology that retains human experience only as a *symptom*.

To speak in terms of symptoms is to redirect phenomenology to psychoanalysis. This move is justified on the grounds that phenomenology alone, in its onus on the descriptive content of lived experience, needs to employ a different language in order situate itself on the underside of experience. The aesthetic image—and more broadly, the realm of the imaginary—enables us to move toward this underside by clothing a nameless, formless thing with a discernible appearance. In this respect, the aesthetic manifestation of a horror that lies beyond experience is structurally parallel to a symptom that manifests itself through the body, and thus marks the trace of a reality that can be approached only through a process of indirection. Both the aesthetic image and the unconscious symptom expose themselves to a hermeneutic analysis, where the alterity of subjectivity gains a counterpart in the experience of horror. In the following section, we shall see how this indirect phenomenology of horror is played out cinematically.

We Are the Martians Now

Amongst other places, the notion of an alien subjectivity finds its expression in the science fiction horror of *Quatermass and the Pit*, directed by Roy Ward Baker (1967). This film is important, as it articulates the paradoxes concerning both an alien subjectivity and a broader phenomenology of the alien. In particular, the film draws out some of the conceptual and affective implications that coincide with the failure to integrate the anteriority of the past

into the present, resulting in an uncanny horror that speaks of materiality as being impregnated with the alien.

The theme of *Quatermass* concerns the discovery of an ancient spacecraft buried beneath the streets of London. Professor Bernard Quatermass, the film's protagonist, discovers that the spacecraft has been covertly influencing the birth and development of human life on Earth. This influence has been made possible thanks to prehistoric locusts, which have been found in the tomb of the spacecraft, their bodies frozen in time. The locusts, we are told, travelled to Earth five million years ago, when their dying planet, Mars, was no longer hospitable to organic life. In need of a new colony, they ventured to our planet and buried themselves in strategic locations so that they might one day again rise in a more intelligent form—a "colony by proxy," so the Professor says. Such a colony was developed through interbreeding with prehistoric hominids. And so it turns out that we—human beings—are nothing less than a manifestation of an alien lifeform, as a government minister says with an aghast expression: "You realise what you are implying? That we owe our human condition here to the intervention of insects!"

In turn, one of the engineers examining the burial site is possessed by a telekinetic agency deriving from the ancient craft, only to later tell the Professor that during the seizure he had a vision of the creatures on Mars. In a discussion with a colleague, the Professor remarks that these faculties may be in all of us, an invariant structure of the subject, to which the colleague replies sombrely, "We are the Martians now." Experiments are then established to record the visions. "What you are about to see... is a memory. Stored for millions of years... and now picked up by the susceptible brain of this young woman here." On a monitor, black and white footage reveals an army of ancient insects roaming across a bleak landscape, "a race purge, a cleansing of the Martian hives," so the Professor says. The memory is one of brutality, of "stored killing," in order to rid the society of

mutations. This history of violence becomes the foundation from which humanity emerges. The violence is not, however, consigned to history. Instead, the pit containing the ancient arthropods continues to emit an energy capable of directing human energy in the present.

In response to this discovery, government bureaucrats proceed to construct a series of rational explanations. At first, they reduce the visions to a product of the overactive imagination before regarding the entire phenomenon as a relic of German wartime propaganda. Both explanations prove inadequate. The dramatic arc to the film's conclusion takes as its point of departure the notion that the human body is the creation of a genetic memory, repressed by civilization and now inadvertently unearthed. This literal case of Freud's "return of the repressed" triggers a series of events that were buried not only in space, but in time, also (Freud 2003).

The history of the human as a history of violence catches up with the present. In response, a society that recognises its own identity as derived from insects with a teleological instinct against that of humanity leads to disintegration and mayhem. As this unfolds, the pod containing the insects emits an eerie blue light, signalling a life that is now being reanimated from the depths of an abyssal time. In the final scene, as the credits begin to roll, the Professor and his assistant stand motionless before a ruined London, traumatised by their confrontation with the abyss from beyond.

* * *

Quatermass is not the only film to contend with fictional possibility that our existence on Earth is thanks in part to an origin elsewhere. Both *The Creeping Flesh* by Freddie Frances (1973) and *Horror Express* by Eugenio Martin (1972) deal with similar material, each in their own subtle ways, and are worthy of further

investigation.[4] More recently, of course, Ridley Scott's *Prometheus* (2012) explores some of these issues in a somewhat less subtle fashion. In the case of *Quatermass*, the theme of the Earth and its relation to the subject as an originary object is conceptualised especially incisively. This is evident in the following ways.

First, the vision of the material past in *Quatermass* is one that is already implicit in a hyperbolic reading of artefacts such as ALH84001 and the extremophiles that lurk in the depths of matter. As we have seen, the discovery of these relics transforms not only our understanding of life, but also our understanding of the places in which those artefacts are buried. Ordinarily, it is of the nature of extremophiles that their existence remains inaccessible to us, save through scientific inquiry. In the case of *Quatermass*, what we witness is the presencing of a prehistory that was, if there all along, then nonetheless invisible. The materialization of this past, evident in both the visions seen in the film and the arthropods themselves, presents us with a disturbed vision of the relation between time and space, which is characterised less by a linear account of evolution and more by what Merleau-Ponty termed a "rigorous simultaneity" (271).

The "visions" seen in *Quatermass* coincide with the perception of the present, forming an overlapping relation between each realm. This shared experience conjoins the living and the nonliving in the same body. This sense of the past and the present coinciding with one another in the same space, able to be reanimated at any time thanks to a phylogenetic (or genetic) memory, contests an account of time as we would usually find it in Husserlian phenomenology. Instead of an arrow that leaves behind a comet's tail, the account of time and space in *Quatermass* is one haunted by the past that refuses to be consigned to an immaterial past, as the Professor says while examining the possessed engineer: "Perhaps it was always in him, in all of us... I think what he gave us was a vision of life on Mars five million years ago." It is no coincidence that such lines anticipate another

33

film dealing with a haunted past that resurfaces thanks to being lodged in space; namely, Kubrick's *The Shining* (1980).[5]

This materialization of the past reveals itself as a history at odds with our established understanding of both the Earth and the body. A third element is introduced, which collapses the Earth/body relation. The element is that of an alien subjectivity manifest through the imaginary sphere as a Martian arthropod. With this image, the subject becomes an alien materiality, not only in terms of an origin, but also in its unknowability. Applied to a Husserlian account of the Earth, the body is no longer tied to the origin of one homogenous space, but instead dispersed through multiple spaces. These other worlds are not mere extensions of the human body as it has been crafted here on Earth, as it is from these other realms that the body itself derives. At stake therefore is not the colonization of the cosmos by Earthbodies, but its exact opposite: namely, the colonization of Earthbodies by the cosmos itself.

This reversibility between the body and cosmos confronts us with the germs of an incipient horror. What we are presented with is the body as the site of a traumatic history not integrated into the subject except in terms of hallucinations and visions. This prehistory is not acquired empirically, but instead constitutes the structure of the subject in the first instance. Affectively, the horror at stake in this corporeal revelation is gained from the insight that one's identity, which was previously thought to be comprised largely of personal memories, is in fact marked by a collective memory of violence. Yet this articulation of body horror is not limited to a prehistory of violence, but is instead implicated in the concept of life itself.

Throughout this chapter, the question of life has assumed a central importance. We have approached the issue in several ways, from theories of panspermia and extremophiles to the question of whether the Earth can be conceived independently of human life. The Husserlian view of the Earth as a foundation of

life provides us with an especially harmonious relation between life and matter. The relation is harmonious not only in terms of its structure, but also in terms of its ability to be represented through the subject, which, for Husserl consists largely of an atemporal transcendental ego. In Merleau-Ponty's account, life becomes more enigmatic, gaining a rich sense of deep time lacking in Husserl. In particular, human life for Merleau-Ponty is one figuration of the body, which at all times is surrounded by a "strange kinship" with the nonhuman. This prehistory marks an aspect of the human that does not lend itself to phenomenology. Rather, the body's origins are at the limit of description, beyond experience, and anterior to subjectivity.

In the cinematic depiction of this non-integrated history, the strangeness of Merleau-Ponty's vision of life takes on a horrific dimension. For alongside the existential horror of a body containing a past other than one's own, a deeper horror unfolds. This is not a horror that can be contained by the body's empirical or lived experience. Instead, a horror assails us that breaks this bond with experience. Beyond phenomenology and science, the horror focuses on an unutterable and altogether abysmal reality called *life*.

The Problem of Life

From the expanse of an infinite void, the stirrings of an embryonic life emerge. Be it from the primordial swamps of New Zealand or Martian fossils, the appearance of life presents us with a fundamental perversion in the cosmos, which, save for that of fossilised worms, is in large part an inert space.

From nowhere, life unfolds. A miracle of being in the yawning abyss of nonexistence. A human being, at once a biological and spiritual entity, takes notice of this surrounding cosmos. At first, the human being regards the world as a living entity, a reflection of spirit which engenders his own existence. Of the trees, plants,

and oceans, he sees his own self reflected in their vitality. In this vision, the human occupies a central position in the cosmos. He is an agent who not only discovers life lurking in the remotest regions, but also gives life itself to the cosmos. Everywhere on his native planet and beyond, the human sees life teeming with a spontaneous possibilities.

As time proceeds, the same species of life begins to discover the place of its planet in the cosmos. Instead of being a centre around which the rest of a system rotates, the planet itself is one of many that rotate around the motionless Sun, which is now elevated to the centre of the universe. A spiritual crisis ensues, from which the melancholy prospect emerges that life, far from a homogenised law of nature, is in fact a freak mistake in the cosmos. Now, it is not life that concerns the finite individual, but the all-encompassing and entirely overwhelming fact of death. In response, the human forges a new set of values that reinforce the sense of life as an interval, which separates us, not from death, but from a second life. Beyond life, another life goes on. It is a life that speaks through the grave, and in doing so, beckons toward a celestial sphere, in which the body is nothing more than the memory of dust.

But in the memory, there is dread as well as affirmation. Those of us who live in the shadow of Copernicus, must choose whether to adopt an eliminative approach to the cosmos or to withdraw into a pre-modern account, which privileges the irreducible enigma of things long before they've been touched by human desire. In each case, we are guided by the fundamental uncanniness of life itself, a life that ostensibly has no place in the universe, except as an appearance of the living dead.

The problem of life enters the stage of thought as an aberration of nature. If life can be characterised in biological terms as a blind striving toward change and growth, then the other side of this striving is the sense of a deformation in the cosmos catching sight of itself being abjected from nothingness.

Nowhere is this realization of the fundamental strangeness of life clearer than in the materiality of the human body.

As Hans Jonas explains, this sense of the body as a strange rupture in an otherwise inert cosmos takes place within an "ontological dominance of death" (Jonas 2001, 12). Into this world teeming with stasis, the body resists being naturalised as a part of the order of things, instead positioning itself as an excess or remainder of a time when "the cosmos once *was* alive" (12). The heritage of this mythical memory, Jonas argues, is the conception of a dualistic metaphysics, which has the advantage of clearly separating the vitalism of the body from the mechanistic system of the cosmos. Such a framework restores the body to its natural place in the world: a temporary shell, the death of which allows the vital spark of the subject to be reunited with the eternal void, as Jonas writes:

> Life dwells like a stranger in the flesh which by its own nature... is nothing but a corpse, seemingly alive by favor of the soul's passing presence in it. Only in death, relinquished by its alien visitor, does the body return to its original truth, and the soul to hers (13).

As this transmutation of the body into a tomb extends to the dimensions of the universe, so it folds back on the spatial phobias of Pascal. The materiality of life in the face of an endless night cannot be approached, except through the lens of anxiety and horror. Today, the problem of life persists as an affront to an otherwise dormant universe. Barring a lapse into Gnosticism, this problem loses none of its intensity so long as we remain committed to either a phenomenological or materialist perspective. The problem of life—at heart, a problem of the uncanny—centres on the knowledge that one's own body (to use a phenomenological idiom) signals a collapse not only in the experience of self, but also in the cosmos itself. For it is in the

privileged expression of the human body that the strange facticity of matter itself gains its clearest expression.

* * *

Far from a vital spark manifest in our experience of things, life understood as an aberration finds itself as without place, and thus beyond representation. In this respect, it cannot be spoken of other than through the aesthetic image, and more specifically, through the articulation of horror. But horror is not a confrontation with life-in-itself, less even the materiality of the biological body, and that alone. Instead, horror marks the point at which language falls into an inchoate abyss, while at all times straddling the line between the body as it presents itself in the phenomenal world and the reality that not only resists description but also destroys the subject.

For these reasons, the emergence of life in the subject does not entail the human body as a unique vehicle of understanding. Instead, the body presents itself as a variant of a formless and indestructible force, a brute animality whose only characteristic is a propensity to disguise itself in other bodies. Because it implicates the existence of the personal body, which all human beings are attached to in varying degrees, horror involves the intersection of the human and the nonhuman. Throughout, the body conceals and reveals itself. It is the site of an intimate knowledge, while at the very same time it withdraws from this intimacy, masking itself in what Lacan would call an *extimacy* (extimité) — that which is unknowable and anterior to the subject (Lacan 2006).

This collision of foreign and alien elements inhabiting the same body is what we term the unhumanity of the body. The human subject is not effaced in the presence of an alien force. It is precisely because the subject and the subject's body persist that its materiality can become the host for another agency. The relation mirrors Merleau-Ponty's *Ineinander* — a symbiotic inter-

twining of different zones of life employing the same body. As this formless life disguises itself, so it reveals itself in a variety of symptomatic appearances. The horror has a face. It presents itself at first as an anonymous field of force, then as an organ of perception, and then finally as the site of reality itself. These three sides to the horror of the body, all underpinned by the brute alterity of life itself, structure the topics of the following chapters.

Chapter 2

Elemental Horror

It is at night, especially when the moon is gibbous and waning, that I see the thing.
H.P. Lovecraft, "Dagon."

"Life," Gaston Bachelard writes in *The Poetics of Space*—on a note of steadfast optimism— "begins well, it begins enclosed, protected, all warm in the bosom of the house" (Bachelard 1994, 7). To the critic, Bachelard's remarks might be seen as emblematic of a kind of failure in phenomenology to think outside an anthropomorphised cosmos, in which the endless void of dark space is nothing less than the warm enclosure of the primal breast. To this end, the critic would have a point. After all, it is hard not to agree that much of phenomenology has indeed failed to move beyond the human realm and has instead emphasized the validity of lived experience as the guarantor of truth.

We see this tendency of aligning "being" and "world" time and again in phenomenology. Indeed, the focus on the inescapability of the human relation to the world is evident in the very formulation that phenomenology advances as its groundwork: *being-in-the-world*. With this innocuous phrase, inherited from Brentano by way of Heidegger, phenomenology commits itself to a view of the subject as constituted by the world and the world as constituted by the subject. Neither idealism nor realism, phenomenology merges the two through the concept of perceptual intentionality, where we—living subjects—are at all times in a relationship with the world.

For Heidegger, the circularity between world and being is taken up in the idea of mood. According to him, mood is the prereflective way in which the world is given its specific experi-

ential significance. In this respect, mood structures our relation with the world: it attunes us to the world, acting hermeneutically to give the world the meaning it has for a living subject. We are *always already*—a phrase that haunts phenomenology—in a mood insofar as our relationship with the world is laden with meaning and never entirely neutral. That we are unable to not be in a mood means that the world can never have a phenomenal status without already being interpreted in a specific way.

This interdependent structure of being and world emerges again in the work of Merleau-Ponty. This time around, the structure of being-in-the-world is provided not by the hermeneutics of mood, but by the hermeneutics of the body. As with Heidegger's mood, the role of the body for Merleau-Ponty serves to place us in a meaningful and intentional relation with the world. Far from mere vessels of the self, our bodies, according to Merleau-Ponty, are the expressive organs of our attachment to the world.

Body and world are equivalent terms insofar as each expresses the other. The world, for him, is not the backdrop against which our actions take place. Rather, the world is defined in a corporeal way in that it is discovered through the body. What this means is that body and world come together in a symbiotic or dialogical structure, both being co-constitutive of the other. In turn, this co-dependent relationship between being and world is mirrored in our relationships with others. Again, it is the body that provides the grounding for our structural and thematic relationship with the other. At all times, our experience of others is mediated via a prepersonal bodily intentionality, which provides a hermeneutic structure of experience.

Mood and body are two ways in which subjectivity is inextricably and pre-thematically tied to the world. Other philosophical structures provide analogous structures in which our access to the world is at all times taken up from the centrality of the human subject, whether linguistic idealism (Lacan and Derrida) or

transcendental idealism (Kant and Schopenhauer). In each case, there are at least two critical consequences for post-phenomenological thinkers.

The first consequence is epistemological. Epistemologically, the apparent limitation of phenomenology is that it fails to contend with the problem of things in themselves, and instead remains restricted to access to the world from the circumscribed perspective of human experience, the implication being that thinking cannot get outside of its determinations. In the words of Quentin Meillassoux, "compare the world as it is 'in itself' to the world as it is 'for us', and thereby distinguish what is a function of our relation to the world from what belongs to the world alone" (Meillassoux 2008, pp. 3-4). Indeed, it is, above all else, in the polemical writings of Meillassoux that phenomenology is faced with its clearest and most challenging critique.

For Meillassoux, phenomenology is illustrative of what he has called "correlationism." According to his thesis, correlationism is the "idea according to which we only ever have access to the correlation between thinking and being, and never to either term considered apart from the other" (5). Although the origins of this thought can be found in Kant, on first glance, it looks as though phenomenology is the exemplary culprit of correlationism. After all, the idea that we can speak for things outside our experience of how they appear "for us" is a kind of phenomenological contradiction. Phenomenology is a philosophy of relationality. It ties us to the world, and in doing so, reminds us that subjectivity is worldly and the world is subjective. So at no point, we can add with a touch of hyperbole, does phenomenology take leave of its senses and grant a reality to things independent to how they are thought or experienced. The tendency of phenomenology to commit itself to the interdependent union of being and world risks becoming a stifling impasse, in which to venture outside of this relation marks a heretical gesture.

According to Meillassoux's criticism, the problem the correla-

tionist faces is not only that the world is unthinkable without the subject; the problem is also that the subject itself is inconceivable without the world. Terming this onus on the relational quality of phenomenology "the correlationist two-step" argument, he goes on to single out the term "co" as a "veritable 'chemical formula'" marking modern philosophy (5-6). This primary focus on the co-constitutional relation between subject and world has, for Meillassoux, lead philosophy away from the problem of substance to an epistemological impasse, in which the leading question is "no longer 'which is the proper substrate?' but 'which is the proper correlate?'" (6).

For modern philosophy, the notion of an outside has become a duplicitous mirror, forever on the verge of a claustrophobic anxiety. It is, he writes, "a cloistered outside, an outside in which one many legitimately feel incarcerated, this is because in actuality such an outside is entirely relative, since it is — and this is precisely the point — relative to us" (7). This vision of a narcissistic outside, in which the greatest exteriority is merely the interiority of a familiar face, marks a failure in modern philosophy. Enclosed within its own boundaries, what has been fundamentally lost in this history is what Meillassoux terms the "great outdoors" (*le grand dehors*). By this, he means:

[An] outside which was not relative to us, and which was given as indifferent to its own givenness to be what it is, existing in itself regardless of whether we are thinking of it or not; that outside which thought could explore with the legitimate feeling of being on foreign territory — of being entirely elsewhere (7).

If his appeal to a great outdoors suffers from a sense of conceptual exaggeration, then it is nonetheless powerful because he captures the urge to escape the suffocating legacy of relational philosophy. Not only this, but his inclusion of a genuine

alterity—or a genuine alienness—within philosophy aligns the great outdoors with an original trajectory in phenomenology that has almost certainly suffered from the preoccupation with inquiring into the "proper correlate," which Meillassoux speaks of.

Alongside the epistemic worries, there is another problem phenomenology faces in the form of its relation with ethics. Ethically, this emphasis on human experience as the centre of philosophy has meant that phenomenology has tended to lean toward a restricted notion of what it is to be human. Characterised above all by an emphasis on plenitude and unity, this employment of a covert *ethics of finitude* infects phenomenology from the outset, masking it with a particular end long before the work has begun in earnest. This is evident in manifold forms. In terms of environmental ethics, phenomenology is often deployed as a means to somehow reinforce our relation to the world, as though the method were here to remind us of this relation in the first instance (cf. Abram 1997).[6]

Meanwhile, the phenomenological onus on the body as the bearer of intersubjective relations has resulted in a homogenised account of the body, divested of a fundamental alterity. Other phenomena likewise are attended to only insofar as they mark the sites of affirmation for the subject. In this reading, death, time, anxiety, and spatiality are taken as irreducibly human concepts. More than this, these same concepts are regarded as having an ethical value, in that they provide an opportunity for subjects to (re)define themselves or their values.

The general outcome of this ethical phenomenology is that the method has been diluted to the point of effacing its receptivity to the nonhuman realm. In this suppression, the method has become aligned with a kind of uncritical affirmation of "lived experience" as a guarantor of truth, and a truth, moreover, which carries with it a teleological orientation toward the ethical function of philosophy. Whether or not phenomenology can aid

in the human need to feel "at home" both on this planet and in relation to others is wholly contingent on its methodology. That it has become concerned with the production of a specific relation to the world—characterised by the preservation of a self-identi-fying union—needs be critically addressed. This is not to suggest that the ethical tendencies of phenomenology can be overthrown with an appeal to a decentralizing of the subject in favour of objects, and that alone. Likewise, the current philosophies of nihilism bear little relevance here, as do the various offshoots of Meillassoux's thinking. Instead, contesting this tradition means articulating a phenomenology, in which the ethical realm is one horizon of experience among many rather than a privileged centre around which thought revolves. Only in this way can phenomenology fulfil its mission in letting things *speak for themselves*.

Anonymous Materiality

In the early Levinas, we find a metaphysics that provides a key— or perhaps a *symptom*—for how phenomenology can think beyond the hold of human experience. Far from the image of Levinas as a philosopher of the face, these early works reveal another side to his philosophy that is characterised less by the face-to-face encounter and more by the facelessness of appear-ances (cf. Sparrow 2013). In these early works, his project is to describe the origins of the subject—an existent—as it appears against the impersonal horizon of existence. Indeed, the whole task of his first book, *Existence and Existents*, is to attempt a phenomenology of the "instant" when the subject appears.

At first glance, it looks as though he is following a tradi-tionally phenomenological line of thought, stating that "a being has already made a contract with Being; it cannot be isolated from it" (Levinas 2001, 1). He thus seems to lock us into a kind of phenomenological prison, in which the inseparability of being

and world is reinforced. Indeed, the inseparability of existence and existent *is* preserved in Levinas. Yet it is precisely for this reason that the rupture of the two terms is possible.

For what Levinas wants to argue in his early metaphysics is that the "adherence of beings in Being" is not "given in an instant... [but]... rather accomplished by the very *stance* of an instant" (2). It is with this elevation of the fractured, indeterminate emergence of the instant that Levinas's philosophy will itself emerge.

The reason for this ontological elevation of the instant is first that the idea of an instant engenders an account of becoming that permits alterity. That the relation of being in Beings is not "given in an instant... [but]... rather accomplished by the very *stance* of an instant" means that Levinas's ontology is fundamentally concerned with the otherness of duration. An instant, for him, is an event, a becoming with its own emergence, which carries with it the arc of an origin, as Levinas puts it: "Beginning, origin, and birth present a dialectic in which this event in the heart of an instant becomes visible" (2). Put another way: if something comes into existence—be it a maggot, a crab, or a dragonfly— then it does so against the backdrop of a generalised and pre-existing plane of Being. Things are born into some-thing, Levinas remarks: "New life figures as the prototype of the relationship between an existent and existence" (10). But a phenomenology of birth alone would not grant us an understanding of the pre-thematic existence. Instead, "We must then try to grasp that event of birth in the phenomena which are prior to reflection" (11).

This something that things are born into is neither the spatiality of our cultural and social world nor the temporality of a history. The general existence transcends the specificity of a manifest thing, as Levinas has it: "Being cannot be specified, and does not specify anything" (2). The question for Levinas is how we can account for this generalised Being without tying it down

to the specificity of things.

The danger here is that of rendering Being local, and of conferring a "personal form" upon it (3). The task is to think outside the personal, while at the same time recognising that only from within the personal can the anonymity of existence be thought. This attempt to conceive an anonymous existence is our first point of departure for developing an unhuman phenomenology.

The *There Is*

Levinas begins by considering the phrase "a world in pieces" (7). Such a phrase is privileged because it marks a rupture with our relation to things. In this rupture, any anxiety experienced is not simply underscored with the knowledge that one day we will die. More than this, it is the "anonymous state of being" that marks a constant threat against the contingency of being a subject (8). In an important passage, he writes: "Existence is not synonymous with the relationship with a world; it is antecedent to the world. In the situation of an end of the world the primary relationship which binds us to Being becomes palpable" (8). In this passage, Levinas is assigning a reality to existence that is not dependent on there being a world in the first place. Rather, existence precedes the birth of the world, marking a constant presence that is at once immersed in the world of things but at the same time resistant to being identified with those things. For this reason, "Being is essentially alien and strikes against us. We undergo its suffocating embrace like the night, but it does not respond to us" (8). At the same time, this pre-human existence also emerges in "the twilight of the world" whereupon the appearance of the subject folds back upon its disappearance.

Given this non-relational account of existence in Levinas, the question emerges of how we can enter into a relationship with the world without existents. In fact, Levinas tells us from the

outset that "the relationship with Being is... [an] analogy," meaning that any attempt to reduce this anonymous world to a localised thing would be all but impossible (8). Moreover, the world without beings is, in his words, "not a person or a thing, or the sum total of persons and things; it is the fact that one is, the fact that *there is* (*il y a*)" (8). This notion of the *there is* will become critical for Levinas. With it, he will try to account for the indeterminacy of existence, which undercuts the anthropomorphism of classical phenomenology.

The *il y a* cannot be explained, nor can it be represented, save as an indirect analogy. It belongs to the shadows and can only be approached in the shadows. Thus Levinas asks us to envision a scenario: "Let us imagine all beings, things and persons, reverting to nothingness. One cannot put this relation to nothingness outside of all events. What of this nothingness itself?" (51) For Levinas, something remains in the nothingness, an excess that underpins the personal realm of silence with an anonymity that is anterior to a subject, he writes: "This impersonal, anonymous, yet inextinguishable 'consummation' of being, which murmurs in the depths of nothingness itself we shall designate by the term *there is*" (52). At ground zero, therefore, the ontology of Levinas gestures toward an anonymous realm that cannot be identified with nor deduced from a particular being, i.e., an "inner world" (52). Beyond the realm of subject and object, interior and exterior, the *il y a* invades these facets of existence without being imprisoned by them.

Nevertheless, the phenomenal realm—the realm of mysterious forests, sunken ghost ships, and craggy mountains—is the site in which the elemental manifests itself. Above all else, though, it is the night which becomes synonymous with the "very experience of the *there is*" for Levinas (52). In his reading, the night assumes a thematic and structurally analogous role to the insidious quality of the *il y a*, remarking that:

When the forms of things are dissolved in the night, darkness of the night, which is neither an object nor the quality of an object, invades like a presence. In the night, where we are riven to it, we are not dealing with anything. But this nothing is not that of pure nothingness. There is no longer *this* or *that;* there is not "something." But this universal absence is in its turn presence, an absolutely unavoidable presence (53).

Far from the mere disappearance of things, the Levinasian *il y a* retains a presence, which cannot be tied down to appearances despite having an indirect relation to those appearances. Nothing is given in this night except "the sheer fact of being in which *one* participates, whether one wants to or not... " (53). This sense of the subject as being implicated by the anonymity of this nocturnal ontology sets in place a vertiginous relationship to the *il y a*. More than an invasion of anonymity, the *there is* marks a "menace of pure and simple presence," in which the finite being is divested of its singularity and subsumed by a "swarming of points," each of which constitutes an eventual *"horror of darkness"* (54. Emphasis added).

Weird Realism

In the twilight, there is horror. This horror marks a threshold, a zone of difference, through which the disordering of light and darkness converge. Light recedes from the world, and a shadowline is created. In that shadowline, the play of light and dark confuses boundaries, masking the everyday world. What is revealed is an abomination masquerading as an appearance. Levinas:

One can also speak of different forms of night that occur right in the daytime. Illuminated objects can appear to us as though in twilight shapes. Like the unreal, inverted city we find after

an exhausting trip, things and beings strike us as though they no longer composed a world, and were swimming in the chaos of their existence (52).

The vision is uncanny. Levinas shows us that the horror of darkness is a space, where things not only die but are also born. Born into the twilight, we catch sight of formless shapes, unbound from their categorisation into "things." The city is inverted. Now, the moon punctuates the daylight creating an insomnia that is no longer limited within darkness but instead becomes constitutive of perception as a whole. Night, hitherto coexistent with an absence of light, seeps into the day, rendering the realm of light and reason a murmuring apparition: "The rustling of the *there is*… is horror" (55).

It is at this juncture that we need to address the place of the subject within this nocturnal topography. If Levinas is able to offer us a way into an unhuman phenomenology, then how can we account for experiences of horror, experiences which are all too human? In fact, just because there is a human with an affective experience does not mean that we are bound by the limits of human finitude. Rather, it is precisely because the human remains intact that the thinking of the unhuman becomes possible.

Here, we can formulate a critical thesis: *Only in the disjunction between the experience of oneself as human and the realization that this same entity is fundamentally beyond humanity is the possibility of an unhuman phenomenology conceivable.*

We see this paradoxical tension as central to Levinas's thought. It is evident most clearly in his account of the subject as "depersonalized" and "stifled" by its confrontation with this pre-human reality (53). "Horror," so Levinas writes, "is somehow a movement which will strip consciousness of its very 'subjectivity'" (55). At the same as it is stripped of its subjectivity, the subject remains present, occupying an event horizon where

the materiality of the physical body outlasts the dissolution of the personal subject.

Insomnia gives us a sense of this strange unhuman subjectivity that persists through the twilight. Insomnia, for him, is not simply an inability or refusal to sleep. It cannot be understood in terms of a negation of sleep, nor as the result of a contingent event in the world, such as stress. Rather, Levinasian insomnia is marked by a porosity of boundaries. The sleeper is not entirely present as subject, but nor is he entirely beyond subjectivity. Existence and existents merge in the space that refuses to give itself over to the dawn.

In the later *Time and the Other*, he formulates an account of insomnia that accents this impossible structure, remarking that: "Insomnia is constituted by the consciousness that it will never finish—that is, that there is no longer any way of withdrawing from the vigilance to which one is held" (Levinas 1985a, 48). This constant vigilance is unwavering and yet without purpose. Its correlating object is nothingness, an "impersonal existence" (48).

Similarly, in a series of interviews collected under the title *Ethics and Infinity*, the formal structure of insomnia is given a thematic content that aligns it explicitly with the horror of becoming unhuman. He writes:

> In insomnia one can and one cannot say that there is an "I" which cannot manage to fall asleep. The impossibility of escaping wakefulness is something 'objective,' independent of my initiative. This impersonality absorbs my consciousness; consciousness is depersonalized. *I do not stay awake: 'it' stays awake* (Levinas 1985b, 49. Emphasis added).

Here, Levinas's "weird realism" comes to the foreground. Materialism—in this case, the materiality of the subject—is not annihilated by the eruption of the *il y a* but instead pushed to the surface in its strange facticity. Materialism, we can say, survives

the twilight. The result is a partly-formed subject, which is present to itself while also being simultaneously conscious of its own effacement: in a word, *unhuman*.

Levinas's claim that "I do not stay awake: 'it' stays awake" captures this double bind between identity and non-identity converging in the same body. Another presence inhabits the body of the insomniac, employing that materiality as a canvas to articulate a metaphysics of anonymity. The body as it is lived—with all its desire and anxieties—is pushed to the background. In its place, the "density of the void" possesses the body of the insomniac, revealing the body as having a reality wholly independent of the experience of being a finite subject (Levinas 2001, 59). In the experience of the unhuman, the reality of materiality persists despite the apparent extinction of subjectivity. It is precisely because things return in the horror of darkness that their reality is accented outside of the subject. Levinas makes it clear that the subject becomes one with the nothing, suffocated by a force that is at once anonymous and immemorial.

Seen in this way, horror is the experience of inversion, a disordering of interiority and exteriority, until nothing remains except materiality rendered spectral/spectrality rendered material. Levinas writes: "The haunting spectre, the phantom, constitutes the very element of horror" (56). The reason for this close relationship between spectrality and horror can be understood in the context of a weird realism. That which outlives its own corporeal extinction is transformed into an entity that is both of-itself and concurrently other-than-itself, both human and unhuman at once.

Here, the human body is shown as having another side that is fundamentally independent of expression and perception. It is not the body of a subject, a body that cannot be approached by phenomenology, still less by introspection. It is a body that is beyond appearances, a "supernatural reality" that resists the ruins of its own negation. Into this abyss, the body as a spectre

comes back from the beyond, carrying with it "an anonymous and incorruptible existence" (57). This is the twilight of the spectre, the night of another metaphysics. There is no exit except in the illusion of the *il y a* receding into daylight. Levinas teaches us a lesson: even in death, the dead remain as elements of the horror of the night, creatures that rise from an absence of life in order to occupy the anonymous existence that remains in the excess of being.

* * *

One of the cinema's greatest depictions of this anonymous materiality returning from the grave is the melancholy *les lieux de mémoire* captured in Tarkovsky's *Solaris* (1972). One scene is especially haunting precisely because it invades our concept of death, anonymity, and materiality. The context is that a psychologist, Kris Kelvin, has left Earth following the suicide of his wife in order to investigate a strange set of circumstances on a space station orbiting an oceanic planet, Solaris. Once there, he finds the station in a state of disarray, the astronauts alive, save for one who killed himself, but in the grip of various maladies. In the midst of these strange happenings, Kelvin's wife, Hari, reappears. Lacking all memory, she struggles to remember or recognise herself. In the face of this spectre, Kelvin makes an attempt to banish both her memory and her materiality, by luring her into a capsule, before dispatching her into outer space. Apparently dead for a second time, later in the same evening that he consigned her to dark space, she appears once more in his cabin. This time around, Kelvin attempts to incorporate the figure of his wife into the present, cognisant of the fact that her presence is a composite of his own memory being fabricated by Solaris—in effect, the projection of a void. In time, Hari forges an identity independent from that of Kelvin, and as a result, becomes aware not only of her own past, but also of her

ambiguous status as human. Horrified by this knowledge, what follows is a key scene, in which Hari attempts to kill herself for a second time by drinking liquid oxygen.

She lies on the floor of the space station, her face motionless with dried patches of blood etched on her nose and mouth. Kelvin looks over the corpse, and a scientist warns him: "The more she's with you, the more human she becomes." Infected by this latent humanity, Hari is unable to die. And at the same time, she is unable to live except as a fragment of a body memory in proximity to Solaris. The scientist makes another plea for Kelvin to annihilate her memory: "She will return. She can return a hundred times over." And then, by way of a spasmodic jerking movement in her neck, Hari returns from the dead once more. The eternal return of an anonymous materiality hinges on the disturbance between the human and the nonhuman. This vision of Hari on the floor is one of pure abjection: a nightmare expelled from the lens of human narcissism, and thus reduced to the facelessness of the Levinasian *il y a*.

In the face of this anonymous matter, a greater horror is yet to come. Once she has awoken from her liquid oxygen coma, a fragment of Hari the human persists in the shell of her body. Having to failed to kill herself again, she murmurs in agony: "Is it me?... No... I'm not... Not her... Not Hari... " This is a scene of primal terror: a subject catching sight of itself as a revenant, inadvertently housed in a nameless body. At the level of brute matter, the body persists blindly, endlessly. Yet through this trauma, the human element is not fully negated. Instead, something of the subject remains, albeit in a dissolved form. This collision of the human and non-humanity inhabiting the same body, with each aspect folding over into the other is precisely what we have termed the unhuman body. The subject, to recall Levinas, is depersonalized through an exposure to the alienness of matter. What remains is materialised abjection, as Hari begs of Kelvin: "Do I disgust you?" This level of disgust not simply a

confrontation with the body in its nauseating facticity. Rather, the horror is aimed the structure of matter itself, which, in its formless origin, consumes all subjectivity in its shadow.

The Spectre of Unhumanity

Phenomenology, as it has been presented until now, faces two distinct challenges. As mentioned above, these problems are epistemological and ethical in nature. Both of these problems constrain the scope of phenomenology, binding it to a predetermined structure. In the case of epistemology, phenomenology remains committed to the view that the world is shaped by the humanity of the body in its interdependent relationship with that world. Ethically, the problem phenomenology confronts is a forgetfulness of the alterity of the body, a result of disposing itself too keenly to instances of bodily unity.

Synthesising these two problems, phenomenology falls into a state of stagnation, an impasse that Meillassoux has described with great precision. The challenge we have posed in this chapter concerns whether or not phenomenology can think outside of its own tradition, and in this respect, return to a phenomenology genuinely receptive to alterity. Has Levinas enabled us to respond to this challenge? Let us examine the evidence.

The scene is both epistemological and ethical; each bound by what Meillassoux terms the correlationist circle. Ethically, it is clear that the subject characterised in the early Levinas resists being defined by the unity of lived experience. Although his thought, of course, will later privilege ethics as a first philosophy, for the moment the picture places less emphasis on the insistence on a face-to-face relation with the world and foregrounds a recognition of the anonymous threat underpinning that eventual relation. In this focus on the pre-ethical subject, he captures the birth of the subject before it has been assigned a particular ethical role in the world. Here, the subject lacks a correlating "home" in

which to find him or herself. And Levinas does not yet advance toward this urge to house the subject in the world. Instead, he gives space for subjectivity to exert its weirdness in a world that is not yet its own.

Epistemologically, we recall that Levinas seeks to contend with a world without beings. *Prima facie,* this move positions him outside of the traditional account of phenomenology as committed to the relation between being and world. The question is: how does Levinas get outside of this relational hold allowing the world to be thought of *in-itself* rather than *for us*?

We can formulate a speculative response in terms of the specificity of Levinas's use of the relation between being and world, as it is articulated in the *il y a*. At stake here is not an intentional relation, less even a "substantive" relation—as that of being-in-the-world—but an indirect relation. This is clear in his use of the term "analogy" (8). Let us recall the passage: "The relationship with Being is only remotely like that; it is called a relationship only by analogy" (8). The *il y a* here emerges as a void in the phenomenal realm, a cut that dissects the relational bind between being and world. Seen in this way, his metaphysics comes to the foreground in its indirection, establishing a withdrawal from the world beyond experience, as he states: "In our relationship with the world we are able to withdraw from the world" (45). That we are able to withdraw from the world— and yet still retain an indirect relation to that world—is only possible because there is a relationship with the world structured at all times by pervasive anonymity.

Experientially, nothing can be spoken of in terms of a world without beings except by way of analogy. In the case of the *il y a*, this indirect experience is of horror. Horror is not a confrontation with a world in-itself, but the marking of the intersection of the world tearing itself from the subject. The horror has two faces. The first face is that of the subject becoming unhuman. The second face is the gap that gestures beyond appearances. With

both faces, horror emerges only to disappear into the murmuring silence. It is a structural opening, whereby different realms are conjoined into the same unhuman body.

The name Levinas applies to this unhuman body is "spectre." With this elevation of the spectral to an ontologically distinct category, Levinas moves away beyond human subjectivity as a *Dasein*—a being there—in order to develop an account of subjectivity that is concurrently both present and absent. The significance of the subject as a spectre in this unhuman phenomenology is to problematize a series of boundaries that have so far anchored phenomenology in an uncritical fashion, not least the boundary between experience and non-experience, and the living and the non-living. Far from siding with one boundary over another, the spectre is that which can both speak of the human while also speaking beyond humanity.

Spectrality is the mark of unhuman phenomenology. It bears the trace of the human as a remnant while also undoing that humanity. As fundamentally liminal, the spectral body traverses different ontological realms without succumbing to the need to unite those realms in an axis of humanity. Here, the body loses its ethical value, becoming a depersonalized assemblage of alien matter to some extent already dead before it has come to life. This living death is evident in that the body is constituted by a plane of anonymous existence irreducible to experience and opposed to our concept of what is "human."

Yet spectrality is not only an invocation of the dead coming to life. Nor is spectrality limited to a refusal to die. Ghosts, revenants, and other entities that haunt our waking dreams gesture toward an afterworld that is in some sense sealed off from human experience. After all, those who go in search of ghosts seldom find them. Only in their haunting *us* do we stand a chance of witnessing a ghost. But the spectrality of the unhuman is of a different order. In the first instance, unhuman spectrality is constitutive of human existence rather than an

abnormal departure from it to be exorcized or mourned. The spectre is there all along, present as an element that unmasks the featureless face of a body that gravitates at all times toward the unrelenting twilight.

Does this transformation of the human to a spectre entail a negation of the subject? Quite the contrary. The weird realism of a materiality outside of the scope of human experience is only possible—paradoxically—because there is a body in the first place. The body is not negated but returns as a foreign presence, as Levinas writes: "Horror is the event of being which returns in the heart of this negation, as though nothing had happened" (57). Indeed, nothing—literally—*has* happened. The body remains in place, its materiality seemingly unaffected by this exposure to anonymous existence. And yet, ontologically it marks a different order of material existence. No-thing intercedes. For this reason, no longer can the body said to be an element in the relation of Being and being. It returns, ontologically disfigured through its transformation into an unhuman entity.

Chapter 3

The Body Out of Time

In retrospect, it is curious that it took me so long to realize that I was looking, not at a real young woman, but at an elaborate mannequin, a masterpiece of the doll-maker's art produced by a remarkable virtuoso. This at last made sense of her Edwardian gown and antique wig, the twenties' cosmetics and facial expression. None the less, the resemblance to a real woman was uncanny. The slightly bowed contours of the shoulders, the too-pearly and unblemished skin, the few strands of hair at the nape of the neck that had escaped the wig-maker's attentions, the uncanny delicacy with which the nostrils, ears and lips had been modelled — almost by an act of sexual love together these represented a tour de force so breathtaking that it all but concealed the subtle wit of the whole enterprise. Already I was thinking of the impact this life-size replica of themselves would have on the wives of my friends when I first introduced them to it.

J. G. Ballard, The Smile

For all its stylistic idiosyncrasies, H. P. Lovecraft's *The Shadow Out of Time* remains an exemplary lesson in the liminal phenomenology of the human body. Published in 1936, the story concerns the fate of Nathaniel Wingate Peaslee, a professor of political economy at the fictional Miskatonic University. From 1908 to 1913, Peaslee suffered a "strange amnesia," preceded by a "singular feeling... that someone else was trying to get possession of my thoughts" (Lovecraft 2008, 556). "The collapse," so we are told, "occurred about 10.20 A.M., while I was conducting a class in Political Economy VI" (557). Professor Peaslee was no longer himself, for "five years, four months, and

thirteen days" (557). In place of the Professor, a second person-
ality had seized possession of Peaslee's body, complete with his—
or *its*—own set of bodily habits.

Although Peaslee's eyes had opened, now those same eyes
"gazed strangely at the persons around me, and the flections of
my facial muscles were altogether unfamiliar. Even my speech
seemed awkward and foreign" (557). With his former self having
ceased to be on the morning of Thursday, May 14th, 1908, the sole
focus of the new incarnation of Nathaniel Wingate Peaslee is to
gain a complete mastery of all branches of human knowledge, his
drive to "absorb the speech, customs, and perspectives of the age
around me; as if I were a studious traveller from a far, foreign
land" (558).

As we later find out, during his amnesia, Peaslee *had* become
a foreign traveller from a distant land. In fact, we discover that
the second personality that intruded upon the body of Peaslee
was neither of this world nor of this time. Shockingly, the subject
that possessed Professor Peaslee belonged to the Great Race of
Yith. The Yith, so Lovecraft tells us, was a race of alien beings
deriving from the Cretaceous era. As their native planet came
under threat, the Great Race transferred their minds to the bodies
of humans on earth, both those bodies in the present and in the
future. Their aim was to preserve their existence and expand
their knowledge. In turn, a huge prehistoric library was estab-
lished in the Australian desert, an entire city containing
knowledge of multiple races from the known and unknown
universe.

While possessed by the mind of the Great Race, the eclipsed
subjectivity of Peaslee was able to experience, albeit in
fragmented dreams and visions, the prehistoric world of the Yith.
There, he witnessed "countless miles strewn with age-blasted
basaltic ruins whose architecture had been like that of the few
windowless, round-topped towers in the haunting city" (566). As
his visions assumed the feel of "pseudo-memories," so the

protagonist, through studious research of similar cases, gains evidence of his fate. Establishing contact with an Australian mining engineer, who yields evidence of ancient "underground huts of great stone," Peaslee travels to the deserts originally witnessed in his dreams.

Once there, the Professor begins excavating the expansive region, in the process unearthing a series of undiscovered stones, sandy chambers, and cryptic corridors. Able to navigate his way through the prehistoric realms thanks to the recollection of oneiric memories implanted in his body, Peaslee eventually encounters his own physical presence in the underground cyclopean city originally inhabited by the Great Race. For in the depth of the city, the protagonist finds a book, which he "pried out of its lair amidst the dust of a million centuries" (606). Of it "no hand had touched that book since the advent of man to this planet" (606). Yet far from being written in an undecipherable, alien language, within its covers, Nathaniel Wingate Peaslee finds "the letters of our familiar alphabet, spelling out the words of the English language *in my own handwriting*" (606).

Between Peaslee and the Yithians

Lovecraft's story of mind-body displacement presents the reader with at least two provisional insights into the phenomenology of the body. First, constitutionally, the human subject can be seen as "sharing" its bodily experience with a prehistoric subject. In Lovecraft's tale, the horror central to the narrative focuses on the struggle between the body as possessor of the subject and the body as possessed by the subject. Such an ambiguity means that once Peaslee returns to his "normal life," the intrusion of the projected mind becomes structurally *of* the self and *other* than the self concurrently. The battle over the ownership of Peaslee's body is exasperated by the fact the prehistoric self is only accessible symptomatically; that is, through dreams and visions. At no

point does Peaslee confront his alien personality directly, and at no point does Peaslee seize possession of the inhuman anonymity lurking within his bodily flesh. And yet, precisely through this indirect awareness, the presence of the other self is given form. Ultimately, this joint ownership of the body of Nathaniel Wingate Peaslee sanctions an uncanny dualism at the heart of the human body.

Second, temporally, this prehistoric constitution sets in place a body out of joint in time, to paraphrase Hamlet. Evaluating his temporal experience, Peaslee states: "My conception of *time*—my ability to distinguish between consecutiveness and simultane-ousness—seemed subtly disordered; so that I formed chimerical notions about living in one age and casting one's mind all over eternity for knowledge of past and future ages" (561). If the first insight questions Peaslee's ownership of his material body, then from a temporal perspective, this ambiguous ownership throws into doubt the personal identity of Professor Peaslee. After all, whose experience is at stake in this collision of the immemorial and the contemporary: Peaslee or one of the Yithians? As the story descends into madness, the two selves become a symbiotic organism, with each spatio-temporal realm inhabiting the same body.

The aim of this chapter is to transplant these two trajectories of thought into a phenomenological context, with particular attention to the philosophy of Maurice Merleau-Ponty. The methodological plan for investigating these weird facets of bodily existence is twofold. First, we will survey the lived dimen-sions of the human body, in the process delineating the salient features that characterise the experience of being a bodily subject. Taking this as our point of departure, we will then turn to some largely uncharted ideas in Merleau-Ponty's early and late works, especially those concerning the prepersonal subject. Such ideas tend to accent the anonymity and alienness of the human body, and thus contest the notion of a sovereign rational subject. As we

will see, the prepersonal body provides the key to unlocking the prehistory of the lived body.

Second, two speculative questions will be pursued, each of which is implicit in the chapter as a whole. One, if the human body is foreshadowed at all times by an alien subjectivity, then can it be said that I "possess" my body? Two, if I am unable to possess my body, then who—or perhaps more pertinently *what*— am I? Such questions will force us to consider the relationship between materiality and alienness, and thus the idea of an alien self.

The Living Body

Our first task is to investigate the phenomenology of the body as it is lived, showing how we ordinarily find ourselves as bodily subjects. Only when we have thematized a sense of the body in its lived facticity will we be able to chart the strange prehistory lurking within that experiential realm.

This inclusion of the body as lived underscores phenomenology's distance from a mechanical model of the body as what Merleau-Ponty terms a "highly polished machine" (Merleau-Ponty 2006, 87). Viewed as an assemblage of material zones, the unity of the body is lost, with an over-emphasis on the physicality of the body's being. Of course, it is true that the human body is subject to certain physical laws. So long as I have this kind of body, it will be impossible for me to live beneath the sea without artificial aid. Likewise, astronauts who remove their suits while investigating alien artefacts on planets other than our own risk endangering their body's organs. The surface of Earth— our planet—is the native homeworld for the human body, and no matter how far the human body travels in space and time, its directional bearings necessarily involve a relationship to the earth, even if, as we have seen in the first chapter, those origins began elsewhere.

What is the body? The question has been asked by phenomenologists time and again, and despite the best efforts of Merleau-Ponty, one may be forgiven for thinking that phenomenology venerates the body as a sort of atemporal entity employed to homogenise the world into a uniform state. In fact, it is precisely with Merleau-Ponty that the body gains a dimension beyond its immediate spatio-temporality. It is worth plotting the development of this movement from lived temporality to geological temporality to get a sense of the body's increasing alienness and anonymity.

Already in Merleau-Ponty's *Phenomenology of Perception*, the temporality of the body reveals a duplicity that prevents us from regarding it as present in a wholly unambiguous way. In the first instance, Merleau-Ponty presents the body as a point of convergence for the structure of time as it is lived by the finite subject. Using the notion of the "intentional arc," he describes perceptual life as underpinned by an arc "that projects around us our past, our future, our human milieu, our physical situation, our ideological situation, and our moral situation, or rather, that ensures that we are situated within all these relationships" (Merleau-Ponty 2012, 137). The point of this description is to reinforce the sense of the body as an anchor in the immediacy of the present. Thanks to the body, time coheres into a unified continuity, establishing a level of stability beyond personal experience.

Elsewhere in the *Phenomenology of Perception*, Merleau-Ponty is even more explicit about the role of the body in unifying time. Of the nature of perception, he writes: "In every movement of focusing, my body ties a present, a past, and a future together. It secretes time ... My body takes possession of time and makes a past and a future exist for a present; it is not a thing, rather than suffering time, my body creates it" (249). This mastery over time hinges upon the interplay of the sensing body and the sensible world, with each bound in a co-constitutive dialogue. Perceptual synthesis—the synthesis of the perceiving thing—is in effect a

temporal synthesis, for Merleau-Ponty.

The Germ of a Dream

Phenomenologically, Merleau-Ponty's account of the body accents the living and lived materiality of subjectivity. For him, the body is an expression of corporeal dynamism, which is irreducible to physical or mental dimensions. To this end, his account of subjectivity attests to the thematic and structural integrity of the body. Yet there is another side to the lived body, a side that enables the personal body to set foot in the world in the first instance. In various parts of *The Phenomenology of Perception*, as well as in his later, more enigmatic writings, Merleau-Ponty will speak of the body as anonymous, hidden, and prepersonal, and at times the resumption of a "captive or natural spirit" (296). This aspect of the body has been curiously overlooked in phenomenological thought, with only a handful of researchers investigating the ambiguities of the prepersonal body (cf. Madison, 1990).

No doubt part of the reason for the marginal status of the prepersonal body is its enigmatic and fleeting appearance in Merleau-Ponty's writings. Indeed, the philosopher himself will time and again refer to the prepersonal body as "the place where life hides away" (190). This move of dissecting the body into a region of life (and thus of death) establishes an epistemic problem of access to the prepersonal body. After all, on the occasions in which the prepersonal body does materialise, it is invariably with an appeal to "impersonal existence," from which the self-conscious I is absolved of responsibility (96).

The impersonality of the prepersonal body is matched only by its pervasiveness. Discussing the relation between sense-experience and perception, Merleau-Ponty goes so far as to say that "if I wanted to render precisely the perceptual experience, I ought to say that *one* perceives in me, and not that I perceive"

(250). This reversal of identities means that the prepersonal body never leaves our side, but instead silently accompanies us at every turn. At all times, an aspect of our perception of things evades the personal subject rendering sensation wholly incomplete.

This move from the particular to the general carries with it a different account of temporality, that is inscribed into the body. At stake in this move is a rupture of lived time and the encroachment of a time outside of conscious experience. Understood in structural terms, the time of sensation assumes a parallel role to the "pre-personal horizon" of birth and death (223). As with birth and death, sensation arises from "beneath myself," and it will continue without me "just as my birth or my death belongs to an anonymous natality or mortality" (224). My existence, such as it finds itself in the present, is masked by "another self that has already sided with the world" long before "I", the personal subject, arrive onto the scene. Sensation removes me from the singularity of my body, forging the space for an *"originary acquisition* that prevents my experience from being clear for itself" (224).

This description of the subject as simultaneously *in-itself* and *beyond-itself* establishes a duplicitous structure to the body. At all times, the phenomenal subject is carried along in the world by a sedimented and impersonal history, manifest in perception yet irreducible to perception. The result, in Merleau-Ponty's words, is that "I never have an absolute possession of myself by myself" (250). Beyond the sphere of personal existence, another subject intervenes in the act of perception, there "confirm[ing] and renew[ing] in us a 'pre-history'" (250). Here, the paradox of Merleau-Ponty's philosophy comes to the foreground. For him, phenomenology is the work of recovering the "unreflective experience of the world" that is anterior to subjectivity while also being implicated by subjectivity (251). At the border of a primordial realm, reflection turns to a prepersonal and prere-

flective source, and there finds, in Merleau-Ponty's enigmatic formulation, "a germ of a dream or depersonalization such as we experience in that quasi-stupor to which we are reduced when we really try to live at the level of sensation" (250).

At the level of sensation, all modes of personal embodiment are thrown into contingency. A collision takes place, and the perceiving body assumes a foreground role. Here, the autonomous teleology of the impersonal body reveals itself. In the depersonalized dream, all that remains is a quasi-stupor, which can be understood as the personal subject perceiving the world in and through the occult realm of the prepersonal body. Thanks to this depersonalized dream, the anonymous body keeps the personal body not only at a distance from itself but also from the world, as he puts it "I am no more aware of being the true subject of my sensation than of my birth or my death" (250). Structurally speaking, I remain anterior to myself, and much of what occurs in the phenomenal realm is beyond my possession. This, too, is the case for my material body, "the life of my eyes, hands and ears... are so many natural selves" (251). Before me, there is "another self which has already sided with world," and as we shall see, the personal self's relation to the other self remains enigmatic and cryptic (251).

Another Time

Coupled with the structural ambiguity of the prepersonal body is an additional puzzle concerning the temporality of the prepersonal body. At the heart of this temporal enigma is Merleau-Ponty's passing reference to an "original past, a past which has never been present" (Merleau-Ponty 2006, 282). To begin to understand the relation between repression and the prepersonal body, let us consult the following lengthy quote:

Thus there appears round our personal existence a margin of

almost impersonal existence which can be practically taken for granted, and which I rely on to keep me alive… Just as we speak of repression in the limited sense when I retain through time one of the momentary worlds through which I have lived, and make it a formative element of my whole life—so it can be said that my organism, as a prepersonal cleaving to the general form of the world, as an anonymous and general existence, plays, beneath my personal life, the part of an *inborn complex*. It is not some kind of inert thing; it too has something of the momentum of existence. It may even happen when I am in danger that my human situation abolishes my biological one, that my body lends itself without reserve to action. But these moments can be no more than moments, and for most of the time personal existence represses the organism without being able to either go beyond it or to renounce itself; without, in other words, being able to reduce the organism to its existential self, or its self to the organism (96–97).

This passage is as striking as it is important. Merleau-Ponty is effectively claiming that the unity of embodiment is made possible thanks to an anonymous subject existing "beneath" my personal existence, such that I am kept "alive" by this absent presence. How am I kept alive? In certain cases, my body "lends itself without reserve to action," establishing a continuity that would otherwise be dispersed, were I simply a mental substance with an attached body. Take the example of the phantom limb. When a human loses his or her limb and still retains the feel of the absent limb, then the persistence of bodily motility is neither reducible to a residual memory nor to a psychological abnormality. The refusal is not, in other words a matter of "deliberate decisions, and [does] not take place at the level of positing consciousness… " (94). Rather, the refusal to accept the loss is thanks to the body's "organic repression" of its own materiality (89). Because of this repressed materiality, the "relation of the

'psychic' to the 'physiological' becomes conceivable" (89). In this way, Merleau-Ponty's prepersonal body serves to connect the intentional arc of the personal subject with the materiality of the lived world, and it does this because there is "an *I* committed to a certain physical and inter-human world" (94). The persistence of the I is thus not simply an aggregation of personal memories, values, and commitments. It is instead the work of an anonymous body, to which the personal I has an ambiguous relation.

This ambiguity is evident in that the work of the prepersonal body takes place in a pre-reflective and pre-thematic way, quite apart from idiosyncrasies of the empirical self. Lacking a self-conscious agency, the teleology of the prepersonal body invokes a "world more ancient than thought" (296). In a critical passage, Merleau-Ponty provides a sense of how the personal and preper-sonal body entwine. He writes:

> My history must be the continuation of a prehistory and must utilise the latter's acquired results. My personal existence must be the resumption of a prepersonal tradition. There is, therefore, another subject beneath me, for whom a world exists before I am here, and who marks out my place in it. This captive or natural spirit is my body, not that momentary body which is the instrument of my personal choices and which fastens upon this or that world, but the system of anonymous 'functions' which draw every particular focus into a general project (296).

Given that the possibility of personal existence hinges upon the prehistory of a subject that not only belongs to me, but is consti-tutive of all human bodies, the singularity of the sovereign self is thrown into question. Am I only the "resumption" of a tradition that predates me? If so, where am "I" in the history of the body? Such questions oblige the personal self to evaluate the materi-

ality of its own being. If the body orients itself toward the phenomenal realm, with its manifold appearances, then the presencing of the prepersonal body draws the personal self into a realm that is beyond time and space, and thus resistant to the specificity of appearances.

This passage offers us a different reading of the human body. As well as the perception of our immediate world, the body is occupied in the retention of a body belonging to a prehistorical realm. This prehistory of the human body establishes a paradoxical structure central to subjective experience. On the one hand, the human experience of being a bodily subject is characterised by the body anchoring and orienting our phenomenal experience. Thanks to the body, we are able to find our way in the world, indeed to *have* a world. To this end, the body is irreducibly *mine*. At the same time, "my" own body is doubled by an anonymous body, which in some sense is not mine owing to its prehistoric anonymity. While it is true that the prepersonal body is constitutive of the personal self, it is at the same time inaccessible, alien, and invisible to the personal self, and thus, critically, marks an incipient threat to selfhood. After all, if the prepersonal body remains alien to personal existence, can we be sure that its buried teleology coincides with our own cognitive intentionality?

In turn, this threat to selfhood forces a double repression to take hold. If the prepersonal body is able to repress the mutilation inflicted upon it by the world, then the personal body assumes an equivalent relation to the prepersonal body. As though avoiding the status of being an organism, and that alone, the personal body proceeds to repress the impersonal existence, which grounds it. As he states it, at no time is the "anonymous and general existence" of which I am constituted freely available to my personal being (97). Only in certain "moments" is the anonymous architecture of being visible, and "these moments can be no more than moments, and for most of the time personal existence represses the organism without being able to either

reduce the organism to its existential self, or itself to the organism" (97). And the reason is clear: *experience* of the preper-sonal, anonymous body carries with it an enigmatic quality, which reason and cognition fail to apprehend. The "captive spirit" at the heart of Merleau-Ponty's subject marks a disquiet, whereupon the surface of the body, in its familiarity and homeliness, becomes the reverberation of an immemorial time, to which human life is still attached.

If this division between the personal and the prepersonal suggests a radical dualism, then any such division is strictly experiential rather than ontological. To be clear, Merleau-Ponty is not presenting us with an inert material body that is given life only by dint of its contact with the immemorial realm of the prepersonal body, as he writes in "Eye and Mind": "The body's animation is not the assemblage or juxtaposition of its parts. Nor is it a question of a mind or spirit coming down from somewhere else into an automaton; this would still suppose that the body itself is without an inside and without a 'self'" (Merleau-Ponty 1979, 59). The structural relation between the personal and the prepersonal is entirely fluid, with each aspect folding over into the other, such that we cannot think of the personal without the prepersonal and vice-versa. The doubling of bodily experience does not, therefore, sanction a dualism even if Merleau-Ponty will elsewhere write that in cases of disintegration, "the soul and the body are apparently distinct; and this is the truth of dualism" (Merleau-Ponty 1965, 209). Merleau-Ponty's admission is telling. With it, an experiential and "apparent" duality is acknowledged despite the fact that phenomenologically speaking, there is nothing metaphysically true about this dualism.

The Abyss in Nature

The human body is thrown into a historical world. There, it finds itself amidst an alien milieu, surrounded on all sides of its flesh

by a culture that predates the birth of its own being. Amid sprawling cities, arid deserts, and swelling oceans, the human body is invited to navigate a constellation of different cultures and worlds, all of which have a persistence that is entirely independent of the perceiving body. "*An Objective Spirit dwells in the remains and the scenery*" (405. Emphasis added). Before the birth of a particular human body, the anonymity of time, together with the "raw material and adumbration of a natural self," continues to persist in the void of pre-natal existence (404).

But this wild materiality does not cease with the birth of the human body. Nor does the human body sublimate the history of its genesis with its own flesh. Looking inward, I discover a "time which pursues its own independent course, and which my personal life utilises but does not entirely overlay" (404). The body belongs to the order of the present, to a subject that has temporarily found a place to dwell on this planet, Earth. But the organic life of the human body is short, and its finite experience of lived time remains incommensurable with the anonymous existence that brought human subjectivity into this world in the first place. As such, the human body is never entirely in possession of its own being, neither temporally nor materially. Turning inward, something evades my reflection. Touching my left hand with my right hand, perception falls short and the body recedes into darkness, a darkness from which no reason can reach.

* * *

We have made a move from the personal body of everyday experience to the prepersonal body lurking beneath and within the flesh of egological self. This move has led us to situate the anonymous agency within the corporeal trace that demarcates the prehistoric from the contemporary. In this series of procedures, we have an unearthed the imprint of the human body as a

union of presence and absence, a symbiotic organism, in which the particularity of the absolute now sits alongside the impersonality of an immemorial era. To delve into the depths of the body, we need to remain with the surface, with the immediacy of experience and, in the very first place, with the sense of ownership.

By "bodily ownership," we mean a pregiven structure of our immediate experience; namely, that one's own body (*le corps propre*) is in a singular and particular sense "mine." Here, the sense of the body as mine means at least two things. First, it means that we spatially orient ourselves in the world with respect to the "primitive spatiality" of our bodies (171). This is clear in our everyday experience of intersubjectivity and inter-spatiality. As my body grabs yours, so your body can grab mine. This interplay of grabbing is predicated on a series of boundaries outlined by the ownership of the body. In a second sense, the claim of bodily ownership means that our concept of selfhood is affectively incorporated into our bodily schema. That is to say, how we comport ourselves in the world is largely an issue of the moods we embody. More than a mass of materiality to orient us in the world, the body is like a "nexus of living meanings," or even a "work of art," in that it presents itself as a totality that can only be understood in a relational and affective context (174).

That the body is both the marker of boundaries and the expressive medium for our being-in-the-world is evidence of its irreducible relation to our nominal sense of being human. To this end, being human means claiming ownership over our bodily subjectivity, the absence of which would render us not only disembodied but also ontologically displaced.

Yet as we have seen, this bodily structure does not begin and end with the personal subject. Instead, it leaks into a prehistory that is constitutive of selfhood while simultaneously being inaccessible to selfhood. This ambiguity precludes absolute ownership over bodily being, paving the way for an agency from

another place and time.

The ambiguity of the human body—the sense of it as both possessor and possessed—forces us to reconsider our ideas of what is living and what is nonliving, human and non-human, alien and non-alien in subjectivity. After Merleau-Ponty, it is no longer sufficient to cite the facticity of the body's materiality as the guarantor of ownership. Something more enigmatic than the lived body protrudes into the life of personal existence, a fossil that bears the trace of an origin still resounding in the hollows of bodily being, and an origin that will outlast the time of the *Homo sapiens* as a species on this earth. Merleau-Ponty thus teaches us that a phenomenology of the body is also archival and archaeological work. It is a phenomenology that revolves around the primordial origins of life, dismantling the phenomenal body as the final stage of corporeality.

Here, Lovecraft's account of liminal bodies traversing the deepest reaches of time and space resumes its importance within the framework of phenomenology. In *The Shadow Out of Time*, Lovecraft joins Merleau-Ponty in giving a visceral account of the relation between the life of the personal subject as an individual finite thing and the life of an anonymous agency deploying its intelligence in and through the finite subject, as he writes: "Had something been groping blindly through time from some unsuspected abyss in nature?" (Lovecraft 2008, 563). For both Merleau-Ponty and Lovecraft, the answer is (to some extent) *yes*. That which journeys through the depths of space of time is an anonymous subject of perception, which renders perception possible and transforms the body's sensory organs into traces of an original time.

In both thinkers, the specificity of the human body as an individual thing is contrasted with a corporeal ontology that is fundamentally alien. If this augmentation of the bodily self produces a sense of the uncanny in Merleau-Ponty, then it is only a question of temperament that the same structure is read as

outright horror in Lovecraft:

> My first disturbances were not visual at all, but concerned the more abstract matters which I have mentioned. There was, too, a feeling of profound and inexplicable horror concerning *myself*. I developed a queer fear of seeing my own form, as if my eyes would find it something utterly alien and inconceivably abhorrent. When I did glance down and behold the familiar human shape in quiet grey or blue clothing I always felt a curious relief, though in order to gain this relief I had to conquer an infinite dread. I shunned mirrors as much as possible (563).

Lovecraft returns us to a problem we encountered earlier, in the form of Merleau-Ponty's apparent truth of dualism (Merleau-Ponty 1965, 209). The alien body that materialises in Lovecraft's story is less a question of an augmented physical form and more an issue of an existential distance from the lived body. Lovecraft reminds us of the self-reflexivity involved in our relation to prepersonal life. The anonymous subject of perception predating life does not stand in a neutral relation to our experience of selfhood, but instead is imbued with an affective quality, shaping our understanding of what it is to be a bodily being in the first instance. The affective relation is felt from the inside out, which in turn accents the fact that there is a material body in the first place, as he writes of Professor Peaslee's rediscovery of his body:

> I used my vocal organs clumsily and gropingly, and my diction had a curiously stilted quality, as if I had laboriously learned the English language from books (561).

This discovery of the body in its alien materiality hinges upon a self-conscious awareness of the body as no longer mine, and thus marks a point of divergence from personal identity. As Lovecraft

and Merleau-Ponty show us, this break of the body from an experience of selfhood is not absolute, but depends on a recognition of the body as simultaneously self and other. Indeed it is precisely because the body is retained in the schema of the self that its growth as an alien rather than inert life is possible. At no point are we fully disembodied. What this means is that the alien within the body is not a departure from the lived body, but a continuation of it. Only now, the body has a spatio-temporal persistence that dissents against our nominal sense of what it is to be human. The creature we are faced with in Lovecraft and Merleau-Ponty is thus a synthesis of the human and the nonhuman, the personal and the impersonal, and the possessor and the possessed. The result of this strange amalgamation is that at no point do we retain total mastery over the archaeology of our bodies, and thus of our own material selves. In an elusive hold on self-possession, we discover another subject intervening in the realm of the lived body.

The Uncanny Body

To help us conceptualize the sense of the body as a site of conflicting temporalities, we can formulate our understanding of the concept with an appeal to the uncanny. Of course, this move to the uncanny is not only helpful in terms of identifying the structure of the body, as a composite of the immemorial and the present, it is also helpful in terms of accenting the thematic quality of bodily nature as characterised by an abiding sense of strangeness. This sense of the body as the bearer of a past, older than thought itself, and at odds with our existing ideas of what constitutes selfhood, finds a special place in Freud's celebrated essay on the uncanny (Freud 2003).

Freud's definition of the uncanny remains exemplary: "That species of the frightening that goes back to what was once well known and had long been familiar" (124). Following an etymo-

logical analysis of the term *"heimlich,"* he notes that there is an increasing ambiguity between the *heimlich* and the *unheimlich,* or the homely and the unhomely, such that neither can be considered in isolation from the other. That which is the most familiar—not least the "home" of the body—is precisely that which engenders itself to estrangement and the intrusion of the unfamiliar.

Following Ernst Jentsch's analysis, for Freud, this dialectic between the homely and the unhomely is evident in objects such as waxwork figures, childhood dolls, and automata, all of which Freud considers by way of Hoffmann's short story, "The Sandman." In addition, the uncanny presents itself in conditions such as epilepsy, given that an epileptic fit "arouse[s] in the onlooker vague notions of automatic—mechanic—processes that may lie hidden behind the familiar image of a living person" (135). What is important to Freud's analysis of such phenomena is that the surface presentation of a familiar thing—in the case of Freud's analysis of Hoffmann's story, the eye—belies another level, in which another meaning resides. It is this other level of meaning that induces an element of intellectual uncertainty, such that despite the best attempts at rationalization, something exceeds reason and thus marks the scene of an ongoing anxiety.

The structure of the Freudian uncanny—characterised as an element of subjectivity repressed into the unconscious while at the same time innocuously persistent in conscious existence— has a particular relevance for the temporality of the body. Indeed, Freud's point of departure for developing his account of the uncanny is the figure of the double, or the doppelgänger.

Following Otto Rank, he observes a shift in meaning of the concept, from its conception as an immortal counterpart of the body to its role as an "uncanny harbinger of death" (142). What is uncanny about such ideas is not simply the factual prospect of encountering oneself as an omen of one's mortality, but rather the very persistence of these ideas, which ought to have been

consigned to a relic of a "primitive phase in our mental development" (143). This persistence of the mythical past in our present existence marks the point at which the semblance of subjectivity falls prey to the voices of a past anterior to our own, whilst still resounding in some buried space within. What was hitherto thought of as an autonomous entity united by its own personal history reveals itself as the site for another past, a past that while invisible and anterior, nevertheless guides the subject in a hidden way.

In cinematic terms, this vision of a buried past coming into the present is a recurring motif in the horror genre, and one to which we will return. The appeal to the uncanny, however, does not always lend itself to the visual image. We are concerned with a moment that is fleeting, if not wholly involuntary. To speak of the horror of the uncanny is to speak of something that cannot be grasped except indirectly. William Friedkin's *The Exorcist* (1973) is exceptional in this respect. One localised example encapsulates the strangeness of the uncanny perfectly.

Toward the beginning of the film, as tension is beginning to mount, we join Father Damien Karras at a subway station in Georgetown. Ascending a staircase, he waits for the train stop. From behind, a man's voice can be heard saying: "Father, can you help an old altar boy, I'm a Catholic." The man is sitting on the floor in the darkness of the subway, surrounded on all sides by rubbish. Karras looks at him, before turning away. The scene cuts. At first glance, we might interpret this scene as a symptom of Karras's crisis of faith, his refusal to offer charity an expression of his inner state. On these terms, the scene adds depth to the character but remains isolated in a specific moment. It is only toward the end of the film, after the viewer has witnessed the horror of seeing Regan McNeil's body (which is now scarred from within, with the words "Help Me" written on its chest) become the host for Pazuzu, that this apparently innocuous voice reappears again. During his first encounter with Regan, as Karras

is attempting to communicate with the body of McNeil, the phrase "Father, can you help an old altar boy, I'm a Catholic" can be heard off screen. Karras turns toward McNeil with a puzzled look of recognition on his face.

The scene is both eerie and powerful. What appeared to be a passing comment on Karras's lack of faith gains a horrific implication if we take the earlier encounter with a homeless man to be in fact a confrontation with Pazuzu. The uncanny is distilled in this act of horror, gaining meaning in a retrospective way—that is, long after the horror itself has begun to impart its presence and thus revealing itself as having been *there all along*.

This sense of being guided by an occult teleology is at play throughout Freud's essay. More innocuous than that of demonic possessions but no less eerie, Freud speaks of himself getting lost in a red-light district of a small Italian town. There, Freud attempts to find his way beyond the district, only to find that each time an escape is made, he returns to the same spot where he began He writes: "I was now seized by a feeling that I can only describe as uncanny, and I was glad to find my way back to the piazza that I had recently left and refrain from any further voyages of discovery" (144). Far from mere "chance," this recurrence of the past—both spatial and temporal—encroaching upon the present derives from a certain "demonic character" in mental life, which lends itself toward the compulsion to repeat (145).

In light of these insights, phenomena such as haunted houses, as well as "anything to do with death, dead bodies, revenants, spirits and ghosts" can be understood as that which belongs to another time, but has somehow managed to survive the advent of rational civilization. Death in particular signals the spot where our conceptual thinking undergoes a process of disintegration, such that superstition, myth, and the realm of the uncanny finds its native haunt. This primal anxiety, where thought takes leave of its senses and the body exposes itself to the spectrality of its own past, is thanks in part to our own ambivalence to death. As

Freud has it, while the logical formulation of death coheres in rational terms—"all men must die"—such knowledge is entirely incompatible with the fact that "our unconscious is still as unreceptive as ever to the idea of our own mortality" (148).

The unassailable structure of death is returned to that of the past. If we are ill-equipped to contend with the notion of death save for that of an abstract or strictly empirical notion, then the same is true of the anterior past. As we have already seen in Merleau-Ponty, perception itself is offset by an atmosphere of anonymity, which incorporates both the futurity of death and the prehistory of our own birth. Both temporal poles are knowable only in abstraction; that is, in terms of knowing that "one" dies, but not that one's own self dies. In this respect, for Merleau-Ponty, "every sensation is a birth and a death" (Merleau-Ponty 2012, 223). In order for a subject to exist, it is necessary that another subject intervenes. This other subject, anonymous and spectral, precedes me, and in doing so, allows me to perceive in the first place. Yet the implication is that everything perceivable by a bodily subject is, in some paradoxical sense, already perceived by the anonymous prehistory of the subject.

In the context of a phenomenology of the body, therefore, the intervention of the uncanny raises a series of doubts over any claim to bodily ownership. Whereas personal existence orients itself toward the gathering of synthesised time, the prepersonal domain resists being situated in time. In retention of a "past which has never been present" (282), prepersonal life generates a simultaneity of temporal experience within the body, thus placing the body fundamentally outside of time. Central to the logic of the uncanny, this dual temporality draws together the living and the nonliving in the same organic body.

That we are able to navigate the world, moving from one place to another, interacting with the things of this world, and communicating with other bodily subjects without use of spoken language, is only possible because *our bodies have been here before.*

Moving through the world, our bodies re-collect the latent knowledge that is retained independently of the phenomenal body. Retained in the primordial body is evidence that the personal body I become attached to is nothing more than an ephemeral expression of an ancient life. When I encounter myself in the world, therefore, I do so through a human body, which is less a testament to the biography of the subject and more a monolith marking a different order of space and time.

The past here marks a counterpart to death, not simply in a temporal sense, but also in the sense of framing the existence of the subject within the reach of the uncanny. If death is thought of as something outside of subjectivity, then the same is true of the past. But in the case of the relation between the body, its prehistory, and the uncanny, the past is operative, articulating itself in a symptomatic way. Through its eerie manifestations, the perdurance of the past (not just its endurance) transforms the body from an expressive organ of perception in the present to a voice of something remote and wholly independent from that of the subject (as we once again hear it in the disembodied voice calling to Father Karras: "Father, can you help an old altar boy, I'm a Catholic"). This undead past generates the sense that the human body, in all its wisdom, is nothing more but nothing less than an archaic relic of a past that refuses to remain buried, as Freud writes of the persistence of primitive beliefs: "Yet we do not feel entirely secure in these new convictions; *the old ones live on in us*, on the look-out for confirmation" (Freud 2003, 154. Emphasis added).

The Flesh of an Insect

The theme of bodies possessed by forces older than humanity itself is a recurring motif in the horror genre. Indeed, the very notion of "body horror," from H. P. Lovecraft to Ken Russell to Georges Franju and David Cronenberg, is predicated on a diver-

gence between the experience of the body as one's own and the reality of the body as belonging to the other. The main distinction between these examples is the temporal scale they employ.

In Ken Russell's *Altered States* (1980), a Harvard scientist experiments with sensory deprivation that leads him to revert back to a primitive state, both mentally and physiologically. In turn, this regression into a human history—albeit one that is far removed from our own—leads to a subsequent regression to the very point where matter itself comes into existence. Russell's film thus signifies a body horror at the very brink of matter and time, an intersection in which identity is subsumed into a primordial origin of life itself.

By contrast, in the Lovecraftian articulation of body horror, we are in the realm of a geological history, which, if belonging to an anterior time, is nevertheless a time that is (to some extent) analogous with our own. That is to say, the Lovecraftian mythos has a topological structure to it, which can be analysed within the context of the phenomenal world. The same cannot, for example, be said of Russell's film, which disintegrates the materiality of the body itself. Lovecraft's world, widely venerated, is classical in its presentation of a material uncanny. If the past plays an important role in Lovecraft, then it is precisely because it retains a relation to the living present rather than negating that past.

In the early films of David Cronenberg, by contrast, we come to the archetypal formulation of body horror in terms of a Cartesian nightmare of personal identity. Films such as *The Brood* (1979), *The Dead Zone* (1983), *The Fly* (1986), and to some extent even *A History of Violence* (2005) all concern an accidental invasion of the body from an agency contained within the subject's history. Thus in *The Dead Zone*, an accident leads to the body of the protagonist becoming imbued with psychic abilities that ultimately lead not only to his estrangement from himself and others, but also his own death. Likewise, in the case of *The Fly*, the drama of the body as a site of existential alienation gains a

visceral role, which pushes to the foreground the body which has a material life of its own, to the extent that it challenges the experience of the body as one's own. His corpus of work, the complexity of which merits another study, is a brilliant testament to the primacy of the body in the structure of the subject. These films, moreover, gain a dramatic quality that reaches beyond the level of "shock horror" thanks to the fact that the temporality of the invading body belongs to the present. As in Georges Franju's film *Les yeux sans visage* (1960), the horror of the body in the work of Cronenberg is, above all, the horror of the facelessness of identity—an identity ravished by what Cronenberg calls "the treachery of the flesh" (Cronenberg 1997, 80). This dynamic of the flesh betraying the subject is especially clear in *The Fly*.

The narrative of this well-known film has a simplicity which belies the complexity of its content. Seth Brundle, an eccentric scientist who suffers from motion sickness, is building a teleportation system used to transport inanimate matter from one point in space to another. At a party, Brundle meets a journalist, Veronica Quaife, who subsequently becomes his girlfriend. Despite Brundle's success at teleporting inanimate matter from one point to another, what is lacking in his research is the successful teleportation of animate matter. Attempts so far at moving a baboon from one space to another have gone severely wrong, resulting in the animal emerging in the other pod in a disintegrated state, its insides now strewn on the floor. For Brundle, what is lost in the act of teleportation is the ability to be "made crazy by the flesh." Having successfully reprogrammed the teleportation module, Brundle directs this molecular deconstruction to his own body. Unbeknown to him, however, a small housefly enters the pod, splicing its genetic constitution with his own. The result: an initial surge of post-teleportation empowerment and super-human ability—said to be analogous to the purification of coffee, evidenced by Brundle's rabid desire for sugar—before a slow and gradual disintegration of the human

flesh. Beginning with the growth of a few thick hairs on his back, the transformation of Brundle into what is now ironically termed "Brundlefly" proceeds through a distinct range of stages: blotchy skin, tightening of the muscles, loss of nails, hair, and teeth, decomposition of the flesh, before arriving at a total transformation of his physical structure. Eventually, this deformation of the human body gives rise to a hybrid organism, composed of fragments of both the human and the fly.

Alongside this corporeal drama, the tribulation of Brundle's relationship with Veronica suffers a parallel disintegration. Consistently sympathetic to Brundle's fragmentation, she nonetheless becomes increasingly alienated by his lack of compassion. Shortly after, the alienation turns to horror, as Veronica discovers that she is carrying Brundle's child, a child that she fears will be severely deformed. This doomed love story reaches a tragic conclusion, as Brundlefly attempts to reunite Veronica and the unborn child into a single entity via the telepods, thus producing the "ultimate family." Aghast at the thought, Brundlefly and Veronica become involved in a physical struggle, with Veronica tearing off Brundlefly's jaw. The tearing of the flesh produces the apotheosis of Brundle's transformation to Brundlefly: a gross, voiceless entity totally deprived of all human attributes except for a forlorn expression in its dark eyes. Having freed herself from the monster, Veronica watches as Brundlefly makes one final leap into the telepod, arriving at the other end a composite of the telepod and flesh, and manifest as an amorphous sludge crawling on the floor. With all hope ruined, Veronica reluctantly cooperates in the assisted suicide of Brundlefly, a shotgun to the head concluding the film.

Throughout this metamorphosis, both Brundle and Brundlefly co-inhabit the same mutating body, each self striving for independence from the other, yet each remaining dependent upon the other for their respective self-unity. A series of paradoxes thus unfolds. Far from being obscured by Brundlefly,

Brundle remains present all along. Only now, the presence is a quasi-presence, caught in the lens of self-doubt, melancholy, and transformation. Binding this ambiguous collision of materiality and identity is the intelligence of the body. In the darkness of selfhood, the identity of Brundle and Brundlefly is thus taken up through the teleology of the body, in both its healthy and diseased manifestations.

The complexity of this relationship between Brundle and Brundlefly is informed by Cronenberg's insistence that we consider how the disease perceives us, the human subject, rather than how the human subject pathologises the disease. As Brundle says when discovering his new ability to climb walls, "I seem to be stricken by a disease with a purpose, wouldn't you say?" Given Cronenberg's commitment to the independent identity of the body, the question would emerge: where is the "I" in this purposeful disease? This reversal of perception leads not only the viewer, but also Brundle, to become voyeurs of the process of this transformation.

Key here is the scene of Brundle looking into the bathroom mirror only to find the future Brundlefly glancing back. As Brundle's nails begin to fall out, the reaction is less horror and more anxiety. The anxiety is inextricably bound with Brundle's discovery of his body as a physical thing in the world, armed with the potential to mutate and readapt itself of its own accord. As Cronenberg writes with this scene in mind: "How many times have you heard stories about someone who just discovers a lump or a blemish or a blotch or something, and it's the beginning of the end?" (Cronenberg, 2006, 87). Phenomenologically, what appears to be unfolding in this body anxiety is the subordination of the lived body by the physical body, a structural distinction originally made by Husserl though now fleshed out in its radical corporeality by Cronenberg.

Becoming radically thematized, Brundle literally catches sight of his body as anterior to his identity — an anteriority that is

independent of, and to some extent in conflict with, Brundle's experience of himself. Thus he asks himself: "What's happening to me? Am I dying?" In one sense, the answer is clearly "yes". Yet the death is ambiguous. While the empirical body of Brundle has begun to detach itself from the world, the "I" of Brundle remains in place. Some-thing is dying, and that death is caught in the anxious face of Brundle gazing at his body, as though it was being colonised by an alien agency.

In all this, it is not only the flesh of the body that is becoming increasingly stricken with disease, but also the means to verbally articulate that deformation. Thus the gradual disappearance of Brundlefly's voice marks an irrevocable transfer from human to fly. This is played out in one especially striking scene. Standing over a command hub, the viewer observes Brundlefly programming his computer in order to purify himself of the fly. Yet the work is thwarted. As Brundlefly gives a spoken order to the computer, an error message flashes on the screen: "pattern mismatch, voice not recognised." The loss of voice instigates a shift in Brundle's metamorphosis. The reason for this is twofold. First, a singular contribution to Seth Brundle's character as a whole is his highly idiosyncratic manner of phrasing sentences, which is at once sporadic and erratic, a tightly pulsating chain of words and silences. In human terms, without his characteristic voice, Brundle is a partial entity, devoid of a mode of expression singular to Brundle the man.

Besides the disintegration of Brundle's personal aspect, there is a more troubling implication to be drawn from this loss of the voice. Not only is Brundle's particular mode of phrasing speech peculiar to him, but without the very function of speech— irrespective of its idiosyncratic tone—the embodied subject as a whole is experienced in an altogether different light. This difference is realised if we take the voice to be between the biological and cultural body. On the one hand, the human voice ascends from the materiality of the body. The voice expresses and

depends upon the body which houses it. On the other hand, the voice is more than a constituent of the human body, establishing a "depth" which exceeds all manner of communication. And this depth is not only personal but also cultural, conferring a complexity upon the human body that prevents it from appearing as an automaton.

The voice that is returned to us when we look another person in the eye gives us reassurance that beyond the screen of the iris, a texture of emotion and desire prevails. Once suspended, this same screen of vision leaves nothing more than a surface with a dark void lurking beneath the flesh. The mute horror that a body without speech invokes is not only the repulsion of something trapped in the body, but is a more elemental dread of the human body as an anonymous thing, no different from inanimate matter. And it is precisely this metamorphosis into the heart of anonymity that we witness in this key moment.

"Pattern mismatch, voice not recognised." With this indictment, Brundlefly places a pencil in his mouth, apparently surveying his lack of options. The stance is broken, however, as contact between the pencil and his mouth snaps the remaining teeth from his mouth, leaving the white fragments to fall on the matt black keyboard. Disarmed, Brundlefly proceeds to examine himself. In a reversal of an earlier scene, we are now back in the bathroom—clearly a pivotal site of transformation in the film. Now, the bathroom is strewn with empty boxes of Cap'n Crunch, a sweet breakfast cereal, discarded in the washing basin. Hunched over, Brundlefly once more confronts the mirror. "You're relics... residual, archaeological, redundant. Of historical interest only" so he proclaims, holding his teeth in the palm of his hand. As he opens the cabinet, the viewer catches sight of another relic: his ear, held in a white, plastic tray. The camera slowly sweeps to the right and we see yet more of Brundle's discarded flesh, unidentifiable body parts archived for posterity. The scene is interrupted by the arrival of Ronnie. "You

missed some good moments," Brundlefly remarks, "... the medicine cabinet is now the Brundle Museum of Natural History."

The horror of Cronenberg's film is the horror that comes with the rupture of the phenomenological body and the return of Cartesianism. The betrayal, therefore, is twofold. On the one hand, the venerated body that appears in phenomenology as "one's own body" (*le corps propre*) is revealed as infected, not simply with disease and mutilation, but also with division. As if it were not enough for the body to undergo decay and disease, in this process the identification with the body as one's own comes radically into doubt. In its place, the nightmare of Cartesianism begins to reappear—a phantom body, bound to subjectivity by association and habit alone. No coincidence that phenomenology's usage of the French term *le corps propre* plays on the ambiguity between the body as one's own and the body as clean. The body's as one's own is not without its exceptions, and the onset of disease and disintegration brings about a conversion of *le corps propre* in terms of both its quality as being "one's own" and its sense of being clean.

Here, we understand "clean" not only in a clinical or sanitary sense, but also in the sense that it is coexistent with the rational approbation of materiality. In Cronenberg's film, what emerges is the horrific implication of the body dissenting from the rational approbation of selfhood. It is as though the body has exceeded its intelligence and, like an exotic variant of an auto-immune disorder, is now producing a body which is no longer "self." Such is the dynamic we witness on a structural level in Cronenberg's account of metamorphosis: it is a world in which the body becomes a strange fusion of being-in-itself and being-for-itself, both alien materiality and centre of lived experience.

Understood in psychoanalytical terms, this fusion of boundaries is essential to the notion of the abject (Kristeva 1982). Kristeva's illustration is worth citing at length:

The abject, has only one quality of the object—that of being opposed to I … A massive, and sudden emergence of uncanniness, which, familiar as it might have been in an opaque and forgotten life, now harries me as radically separate, loathsome. Not me. Not that. But not nothing, either. A "something" that I do not recognize as a thing. A weight of meaninglessness, about which there is nothing insignificant, and which crushes me. On the edge of nonexistence and hallucination, of a reality that, if I acknowledge it, annihilates me. There, abject and abjection are my safeguards. The primers of my culture (1–2).

Throughout this essay, Kristeva places the self on the border of extinction. She writes: "The border has become an object. How can I be without border? … Deprived of world, therefore, I fall in a faint" (4). Abjection involves the dissolution of borders, thus leading to the engulfment of the subject in the contingency of its existence, a contingency, moreover, that no law can prohibit. This uncanny materiality gives us the impression of the subject's (re)birth as involving a violent tear in creation. In coming into existence, castration anxiety is replaced with an anxiety of claustrophobia, a repulsion that is directed at the womb, the place where primal repression is located: "The abject confronts us, on the other hand, and this time within our personal archaeology, with our earliest attempts to release the hold of maternal entity even before ex-isting outside of her… " (13). In this way, abjection marks the primordial origin of the subject, the first response to the suffocation of being an interiority within another interiority, and thus as much a living womb as a *living tomb*.

Kristeva is more attuned to the improper element of the body than Merleau-Ponty. Yet despite Merleau-Ponty's own use of *le corps propre* , the horror emblematic of this conflation between subject and object is there all along in the ambiguity of his thinking, an ambiguity that resists the limitation of both inside

and out, as Merleau-Ponty puts it: "The body catches itself from the outside engaged in a cognitive process" (Merleau-Ponty 2006, 107). At such times, the body enters into a dialectic with cognitive thought, and in doing so, instigates a different experience of being an embodied subject. Seen in this way, by revisiting the scene of Brundle looking at himself in the mirror—surely the archetypal articulation of abjection—the gesture of catching oneself is presented as a moment of self-discovery. And yet, it is a discovery of oneself as giving birth to a self who is incommensurable with the body in transition. This horror of what the mirror both reveals and conceals leads us from the existential body horror of Cronenberg to the cosmic horror of Carpenter.

Ghosts, Shadows, Mirrors

Besides Cronenberg, it is in the works of John Carpenter that we gain the broadest overview of the horror of the body, from the possession of the body via Lovecraftian gods to the reduction of matter to primordial evil. This arc of horror finds its clearest expression in three films which bear the thematic title, "Apocalypse Trilogy," *The Thing* (1982), *Prince of Darkness* (1987), and *In the Mouth of Madness* (1995). Considered together, the trilogy provides a detailed analysis of the rapport between the horror of the body and the materiality of the universe more broadly. Indeed, Carpenter's contribution to the body horror genre is to contextualise the subject against the backdrop of an indifferent universe, a scope that is lacking in the otherwise more precise dissections of the body in the work of Cronenberg.

Of the first—and arguably most important—film, we shall reserve comment until the conclusion of the present book, at which point its insights can be fully appreciated. Each of the latter two films testifies to the brooding horror of a past, hitherto dormant, which articulates itself as a fundamental rupture of reality. True to his Lovecraftian origins, Carpenter presents this

disturbance of reality as a confrontation with a cosmos that is at best indifferent, at worst opposed to humanity.

In Carpenter's *In the Mouth of Madness*, Lovecraftian horror finds a voice not simply in those "terrifying vistas of reality" which lead us to "go mad from the revelation or flee from the light into the peace and safety of a new dark age," but in the very media of cinema and literature themselves as forms of contagion (Lovecraft 2008, 201). Whereas the earlier films concern themselves with a dormant past, discovered by accident, which then brings about an end, in this later film, the horror has already infected us through the medium in which it is presented.

The film concerns the search for the disappeared best-selling horror writer Sutter Cane (Jürgen Prochnow), by insurance investigator John Trent (Sam Neil). Reports surrounding Cane's work have claimed that it can drive the reader insane, making them paranoid and violent. At first, John Trent dismisses such claims on the pretext that these reports are essentially marketing devices. Cane, meanwhile, is convinced that his writing is creating reality, and for this reason has driven himself into a state of self-exile. As the film proceeds, Trent becomes increasingly absorbed in the world of Cane, complete with nightmares and symptoms of paranoia. In turn, Trent pieces together torn fragments from the covers of Cane's book, to reveal that they form a map leading to Hobb's End (a reference to Carpenter's longstanding affection for the work of Nigel Keane). Once at Hobb's End, it becomes clear that Trent is in fact a part of Cane's new book, and thus that his reality depends on the creation and destruction of Cane himself, as Cane remarks: "You are what I write… I think, therefore you are."

This negation of free will and agency is at the heart of the film's Cartesian horror. As with Carpenter's other apocalyptic films, the horror comes in the form of a possession of subjectivity by another force. Only now, the horror centres less on the invasion from beyond and more on an invasion from within. This

inversion of horror, together with Carpenter's violation of the fourth wall, is not contained within the film itself, but instead dissolves the very boundaries between the spectator and the spectacle. Thus, at the end of the film, Trent, (who having apparently broken Cane's spell by breaking through a wall made from Cane's text, leaves behind his assistant, who is consigned to Cane's fate, having "read to the end,"), finds himself at a cinema.

In the midst of an urban chaos, the cinema is showing a film: *In the Mouth of Madness*. As Trent approaches the poster, it is revealed that the film is not a fictional invention depicted within the world of the film itself. Instead, Trent's film is Carpenter's own, and thus our own—the very same *In the Mouth of Madness*, which we have exposed ourselves to. Such a horror is not restricted to the frame of the cinema, but instead bleeds through the medium, infecting both us and those who come into contact with us in the process. This blurring of reality and non-reality, and of intellectual uncertainty and doubt, culminates with the image of John Trent watching himself on screen proclaiming *"This is not reality!"* In response, Trent the viewer falls into a frenzied laughter, apparently having succumbed to what Lovecraft aptly described as an "austral world of desolation and brooding madness" (Lovecraft 2008, 448).

* * *

In the case of *Prince of Darkness*—arguably Carpenter's most underrated film—this Lovecraftian theme of awakening horror is present from the outset. The plot of the film concerns the discovery of a cylinder buried in an abandoned church containing a slimy green liquid. We find out that an ancient Roman Catholic order called the Brotherhood of Sleep has been watching over the liquid for centuries. Until now, it has been hidden in the crypt of the church, repressed within the earth. After the last guardian dies, another priest (played by Donald

Pleasence) calls upon Professor Howard Birack (played by Victor Wong), specialist in theoretical physics, to investigate. At the request of Professor Birack, a team of PhD students moves into the church to study this emergent secret. A text is discovered in the crypt, written in several languages. Traces of Latin, fragments of Coptic.

This gesture of an ancient past returning from the tomb of the Earth to possess humanity is, of course, a theme we have already seen in *Quatermass and the Pit*. Carpenter's own film is an extended homage to *Quatermass*, such that Carpenter wrote *Prince of Darkness* under the pseudonym "Martin Quatermass." This identification with the *Quatermass* legacy (and the work of Nigel Keane more broadly) is captured in the play of themes in Carpenter's film, not least the sense of an unburied past endangering, not just a set of select individuals, but society more broadly. Thus, at the same time as the scientists begin their research, strange things begin happening in and around the church. A horde of homeless people—one of whom is played by Alice Cooper—stand transfixed by the church, their presence a symptom of the horror dwelling within the building.

As the plot proceeds, one of the research team begins to gain a sense of what is happening with the green liquid, remarking to the Professor: "A life form is growing out of pre-biotic fluids. It's not winding down into disorder, it's self-organizing. It's becoming something. What? An animal? A disease? What?" Soon after, the hermetic text reveals the liquid as the embodiment of the Antichrist. The container, so a scientist remarks, was buried in the Middle East "aeons" ago by "the Father of Satan," who in this incarnation, resembles a pre-human Lovecraftian entity. In this history, the figure of Christ is discovered to be of extraterrestrial origins, sent to warn humans of the latent evil buried in the Earth. The history remains concealed until science discovers the means to verify Christ's prophecy, which leads us to the present situation—an abandoned church in Los Angeles, 1987.

This history of a green liquid in turn leads to a revaluation of evil itself. Until now, evil had been thought of as an immaterial spirit that lurks within humans themselves. This appropriation of evil has the advantage of retaining the centrality of human existence. Carpenter's film denies us even this basic value. His is an evil, not only in a moral sense of the term, but in the sense of marking a materiality outside of humanity, as the priest remarks mournfully: "A substance, malevolence. Asleep, until now."

As all of this is happening, the liquid is beginning to strengthen. Members of the research group are becoming possessed by the liquid or otherwise killed off by the glazed-eyed homeless people surrounding the church. One member of the group begins to display symptoms of stigmata, a cross (later revealed to be an astrologer's staff) etched into a bruise on her arm—her body becoming a canvas to be hermeneutically deciphered. Another member stares vacantly into her computer screen. in an apparent gesture to the frenzied possession of Jack Torrance from Kubrick's *The Shining* (1980), a message is repeated *ad infinitum*: "I Live, I Live, I Live, I Live, I Live, I Live, I Live, I Live" and so on. In the meantime, each member of the group has an apparent dream. A dark figure appears against the backdrop of the church, and a voice from 1999 is heard:

We are using your brain's electrical system as a receiver. We are unable to transmit through conscious neural interference. You are receiving this broadcast as a dream. We are transmitting from the year one, nine, nine, nine. You are receiving this broadcast in order to alter the events you are seeing. Our technology has not developed a transmitter strong enough to reach your conscious state of awareness, but this is not a dream. You are seeing what is actually occurring for the purpose of causality violation.

They speculate on what the vision is, entertaining the prospect

that it might be a precognitive message or a "tachyon" emitting from the message—that is, a sub-atomic hypothetical particle which allows for faster-than-light communication, the purpose of which is to repeat the disrupted warning brought by Christ. Only now, the message is sent from the future and not from the past.

As the film reaches a conclusion it descends into a black melancholy. This descent into gloom is accented at all times by Carpenter's soundtrack, which, in its relentlessness, gives the film an atmosphere of bleak fatalism. This gravitational descent toward an abject origin returns us to the horror of the body. The theme is articulated in the body of the possessed student, the first to come into contact with the demoniacal liquid. Her body as it is presented now is bloated, with a series of inner convulsions taking place beneath the skin. On the skin, a series of gelatinous protrusions have begun to appear, each of them bearing the mark of some trauma. Finally, those same protrusions give way to a bloody canvas lurking beneath the scarred flesh. Something is beginning to materialise in the flesh, transforming both the spirit and the matter of her subjectivity, rendering her, in the words of the Professor, a "host in which to live—a parasite growing into its host."

Once possessed and fully incarnate, she proceeds to take possession of those around her. Yet the embodiment of evil is not without the residue of a human ambiguity. At one point, the possessed subject, her face disfigured by bloody scars, turns to a mirror. In it, she catches sight of herself, and with an expression of both ecstasy and horror—one thinks of Bataille's discussion of the erotic horror of *lingchi*—mutters the word "Father" into the reflection. Her hand peers through the mirror, touching the hand of Evil on the other side, before attempting to return that hand to the Earth itself. The attempt proves a failure. Another of the research team storms into the room, throwing the possessed into the mirror and sacrificing herself in the process. Once on the

other side, the priest throws an axe at the mirror, breaking the relation to the phenomenal world and trapping both the possessed and non-possessed subject in the other realm.

* * *

If Carpenter's film suffers from several gaps in its narrative structure—not least, the question of why a variant of Christianity must wait until science is sufficiently advanced to verify its faith-based claims—then what the film nevertheless excels in doing is articulating not simply the horror of the body, but the horror of matter itself. Already we have glimpsed at the traces of Carpenter's particular type of body horror in our dealings with Merleau-Ponty, Lovecraft, and Freud.

In Merleau-Ponty, we have seen how the personal body is foreshadowed by the remains of an anonymous body, sedimented in the flesh and there *all along* (to repeat the mantra of the uncanny). In turn, this renders the body the site of multiple temporalities, both immemorial and particular. Here, Merleau-Ponty finds himself in the company of Lovecraft, insofar as both are concerned with the materiality of the body before it has assumed a human form. In our turn to Lovecraft, we see that the horror of the body is a horror transfixed on the alterity of things. In Lovecraft, the body becomes the stage upon which a history other than our own is written. The next phase in this evolution of horror is the Freudian appropriation of the body as a burial site. If the primitive past is there all along, then it nevertheless resurfaces in another guise. Thus, what the Freudian uncanny reveals is that the strangeness of the body is, in effect, the estrangement of the body from its own self.

From Freud to John Carpenter a move is made, from the uncanniness of the body in relation to a primitive past, to the uncanniness of matter. To be sure, the human body as a particular thing loses none of its value in Carpenter's work. Indeed, the

motif of characters gazing into mirrors in order to verify the existence of their humanity is central to *Prince of Darkness*. The very final scene of the film culminates in a prototypical Lovecraftian moment, where the apparent vindication of humanity over malevolent materiality is proven to be an illusion. This takes form in the repetition of the prophetic dream. This time around, the figure in black is revealed as one of the students themselves, who has evidently been possessed from beyond. The leader of the research group wakes up to find her mutilated beside him, only to realise that the vision is a hallucination. He wakes again and makes his way to the bathroom. There, he stares at himself in the mirror, reaching his hand toward it, unsure of what lies both beyond the mirror, but also of what is in front of the mirror.

The scene is the cinematic counterpart to Lovecraft's "The Outsider," which surely contains some of Lovecraft's finest prose. Here, too, the horror of the body becomes the horror of catching sight of oneself in the mirror. The story concerns a deformed monster, imprisoned for too long in the basement of a castle, who finds its way to the "gayest revelry" taking place in a nearby apartment. As the monster approaches the scene of warmth, he finds that those who see him flee for their lives: "The nightmare was quick to come; for as I entered, there occurred immediately one of the most terrifying demonstrations I had ever conceived" (Lovecraft 2008, 145). At first, he is naively unaware of what causes the disturbance. Once more, he is alone, in an abandoned room. He sees something abysmal, which Lovecraft describes thus:

I cannot even hint what it was like, for it was a compound of all that is unclean, uncanny, unwelcome, abnormal, and detestable. It was the ghoulish shade of decay, antiquity, and desolation; the putrid, dripping eidolon of unwholesome revelation; the awful baring of that which the merciful earth

should always hide. God knows it was not of this world—or no longer of this world—yet to my horror I saw in its eaten-away and bone-revealing outlines a leering, abhorrent travesty on the human shape; and in its mouldy, disintegrating apparel an unspeakable quality that chilled me even more (145).

Slowly, the realization begin: "My eyes, bewitched by the glassy orbs which stared loathsomely into them, refused to close; though they were mercifully blurred" (146). Lovecraft's description of the emergence of a reflection is uncanny and brilliant. The horror is not simply visual horror, but also a horror of identification, in which the mirror returns a gaze that is both of the self and other concurrently. By the end of the story, Lovecraft's existential castle freak finds some repose in this horror:

For although nepenthe has calmed me, I know always that I am an outsider; a stranger in this century and among those who are still men. This I have known ever since I stretched out my fingers to the abomination within that great gilded frame; stretched out my fingers and touched *a cold and unyielding surface of polished glass* (146).

Beyond this existential level of horror and self-identity, Carpenter's film extends its scope to the horror of matter more broadly. This sense of matter becoming imbued with a strange, alien quality is evident throughout Carpenter's films. From cars (*Christine*) to books (*In the Mouth of Madness*) to pieces of driftwood (*The Fog*), it is not only human bodies that become possessed with an agency other than their own. In the case of *Prince of Darkness*, the infection of matter takes form in the shape of insects first, then moves to human bodies. As these various artefacts transform, so they change form, disclosing their identity

as contingent and in the process cultivating a parasitic relation to the human bodies which become their hosts.

This reversal of subject-object relations means that what is ostensibly an object for a human—a book, or a car—reveals another side that is no longer dependent on the human gaze. In each case, matter is alive, as the priest says: "He lives in the atom. He lives in all things... " Not in an animistic rapport with humanity, but in an anonymous and brute way. This is the horror of the Levinasian *il y a*—the horror of the it which refuses to reveal itself as an I, except as a symptom or a dream. In this vision of horror, matter exceeds the confines of the flesh, and thus subjectivity itself. Doing so, the structure of reality loses definition. Accordingly, in a key scene at the beginning of the film, Professor Birack suggests the following thought to his students:

> Let's talk about our beliefs, and what we can learn about them. We believe nature is solid, and time a constant. Matter has substance and time a direction. There is truth in flesh and the solid ground. The wind may be invisible, but it's real. Smoke, fire, water, light—they're different! Not as to stone or steel, but they're tangible. And we assume time is an arrow because it is as a clock—one second is one second for everyone! Cause precedes effect—fruit rots, water flows downstream. We're born, we age, we die. The reverse never happens... None of this is true! Say goodbye to classical reality, because our logic collapses on the subatomic level... into ghosts and shadows.

Carpenter's vision—as told by Birack—presents us with a reversal of the phenomenal world. This is the ultimate Humean nightmare in which causality really does bring about a collapse in the natural laws. Once more, the horror of this mutation takes place in the figure of a mirror: not simply a mirror which reveals

our own alterity as human subjects, but also a screen that beckons the horror of the cosmos itself. We leave the final words to Professor Birack:

Now, every particle has an anti-particle. Its mirror image. Its negative side. Maybe this universal mind resides in the mirror image instead of our universe as we wanted to believe. Maybe he's anti-god, *bringing darkness instead of light*.

Chapter 4

The Flesh of the Thing

The existence of the void at the centre of that reality called the Thing.

Jacques Lacan, *The Ethics of Psychoanalysis*.

In 1951, the British philosopher A. J. Ayer found himself in the midst of a late night encounter with Merleau-Ponty, Georges Bataille, and a friend of Bataille's, a physicist named Georges Ambrosino, in a bar in Paris.[7] During that meeting, the question was raised whether the sun existed before humans were alive to experience it. According to a report by Bataille, Ayer responded in the positive, stating unequivocally that there was no doubt the sun did exist prior to human perception. Bataille and Merleau-Ponty, on the other hand, were ambivalent about the prospect, as Bataille's report confirms: "Ayer had uttered the very simple proposition: there was a sun before men existed. And he saw no reason to doubt it. Merleau-Ponty, Ambrosino, and I disagreed with this proposition, and Ambrosino said that the sun had certainly not existed before the world. I, for my part, do not see how one can say so" (Bataille, 1986, 80).

This was not the first time Merleau-Ponty had contended with the question of the world prior to the advent of the human subject. In fact, it appears several times in his thinking. Most clearly, the discussion appears at the end of a chapter on temporality in his *Phenomenology of Perception* (Merleau-Ponty 2012, 454). In this work, the debate between realism and idealism is central to what is ostensibly Merleau-Ponty's formulation of classical phenomenology. For him, the task is not to refute idealism or realism, but instead to incorporate both of these perspectives into a phenomenological account of the body as

prior to the dichotomy of realism and idealism. At the same time, what will become Merleau-Ponty's archaeological phenomenology—a phenomenology on the cusp of the unconscious—is already evident in his early thinking. Through the *Phenomenology of Perception*, the germs of what will later be conceptualised as Merleau-Ponty's *realism* can be traced out from their origins.

The question concerning the sun before humanity is not a trivial or flippant one, but instead marks the very limit at which phenomenology either withdraws inside itself or expands to register an alterity outside of experience. Based on this discussion of the elemental sun, in the present chapter, a phenomenological realism will be constructed from the work of Merleau-Ponty, which responds directly to the challenges put forward by Quentin Meillassoux, specifically in his concept of the *arche fossil* (Meillassoux 2008).

Before the Earth

Merleau-Ponty's discussion of the world prior to humanity takes place in the context of an analysis of time. At first, his account assumes the form of a classical Husserlian analysis of time; namely, that we are only able to understand time thanks to the fact that we are inside it (Merleau-Ponty 2012, 454). Time opens itself up to us through its accessibility in experience, and for this reason has the structure of being present (455). In its presence to us, time is given in and through the body. Once more, Merleau-Ponty employs time in making the distinction between the lived and the objective body, a motif that runs throughout this phase of his thinking. If subjective experience gives us access to the undeniable richness of the body, then the objective image of the body as an assemblage of parts is "merely an impoverished image of the phenomenal body" (456).

Against this background, the question of the "world prior to man" assumes its importance (456). Merleau-Ponty stages a

dialogue with an imaginary interlocutor: "The world preceded man, that the earth, according to all the evidence, is the only populated planet, and that thus the philosophical views are revealed as incompatible with the most established facts" (456). Merleau-Ponty responds to the question by reducing it to an "abstract reflection of intellectualism" (456). Even if this is the case, as he suggests, then what is nevertheless presupposed is the prior experience of the world before it is scientifically abstracted, as he writes tersely: "Nothing will lead me to understand what a nebula, which could not be seen by anyone, might be" (456).

At first glance, the prospect of formulating a phenomenological realism able to respond to challenges put forward by Meillassoux concerning the pre-subjective status of the world seems destined to failure. Based on the above reading, Merleau-Ponty appears committed to a phenomenology that leans more toward Husserlian idealism than a variant of realism. Yet this is only half the story. In fact, a version of perceptual realism is already detectable in the earlier works of Merleau-Ponty. But some time will pass before this perceptual realism appears as a cosmic realism. To trace this lineage, we need to return to the *Phenomenology of Perception*, and specifically the chapter on "The Thing and the Natural World."

* * *

In the chapter on the natural world, Merleau-Ponty takes up a phenomenology of the thing. The question is posed: What is a thing? At first, it is precisely that which appears for us, a composite of form and content, arranged in such a way that it has a constancy that aligns with our perceptual experience. Not only this, but world and perceiver are related such that a natural harmony exists between them. In this regard, Merleau-Ponty speaks of an "optimal distance" between an art work and its

viewer (316). The idea is that a pre-reflective dialogue implicates the body and the world long before they are abstracted conceptually. Likewise, when I look at my body in a certain way, it loses its meaning as a horizon of experience and instead becomes "a material mass as strange as the lunar landscape" (316).

To look at the body and see it as an alien landscape requires a certain type of perception. It is a perception that forges a distance from experience while at the same time retaining the materiality of that experience. We have seen this bind between the body as a site of experience and the body as a site of anonymity throughout the current book. It figures as a central motif in our formulation of the unhuman body and plays an equally important role in the untimely quality of the body as the bearer of multiple timescales. Throughout, there is a sense of the body as a duplicitous entity, open to appearances while at the same time masking a world beyond that of subjectivity, and thus belonging to another time and place. This duplicity is not limited to the body, however, but also impinges upon things more broadly.

Once more, we are faced with an ambiguity in Merleau-Ponty's thinking, which centres on the struggle to move beyond Husserlian phenomenology. The resistance is inherent in his account of the thing. Thus, from one perspective he seems to "fold back" on the Husserlian tradition by saying that "the thing is the correlate of my body... The thing is constituted in the hold my body has upon it" (334). As he makes these remarks, however, he acknowledges that such thoughts are not equal to the real, stating that "if we want to describe the real such as it appears to us in perceptual experience, we find it burdened with anthropological predicates" (334).

This sense that phenomenology falls short of the real is confirmed in the following pages of the chapter. What happens when we conceive of a thing that "can never be separated from someone who perceives it?" (334). In answering this question, Merleau-Ponty breaks away from his phenomenological founda-

tions, writing that "we have not exhausted the meaning of 'the thing' by defining it as the correlate of our body and our life" (336). Under certain modes of perception, so he suggests, the familiar way in which we approach the thing in its human and relational context is breached by a recognition of the "non-human element which lies hidden" in all things, and which is "unaware of us, it remains in-itself" (*"la chose nous ignore, elle repose en soi"*) (336). By turning to things with a "metaphysical attention," the thing reveals itself as "hostile and alien, no longer an interlocutor, but a resolutely silent Other" (336).

The inclusion of "metaphysics" in this passage signals the passage to Merleau-Ponty's later phenomenology, a phenomenology that moves beyond the veneration of lived experience and now recognises the resistance of things that do not conform to experience. But not only is the non-human world hidden in all things, it is also alien and hostile, resistant to the human desire for dialogue.

This sense of a non-human world alien to perception and resistant to integration is, in fact, a central theme of Merleau-Ponty's thinking. It is as much evident in his late writings on psychoanalysis as it is in his early work on Cézanne. Indeed, it is in Cézanne that Merleau-Ponty continuously finds "a pre-world where there were still no men" (337). Merleau-Ponty's incipient account of the real puts it in terms of a resistance to experience, a tear in the field of appearances into which something alien enters. If our experience of things is ordinarily given in a typical phenomenological manner, then Merleau-Ponty's admission of an alien reality lurking behind appearances marks a turn in his phenomenology that can neither be wholly repressed nor forgotten. With it, the seeds of an unhuman phenomenology can be found.

This early engagement with the real marks an ambiguity in Merleau-Ponty's approach to the world prior to humanity, an ambiguity, which, by the time of his late thinking, signals a move

toward a non-phenomenology. Thus, in his commentary on Husserl's fragment on the Earth, which we encountered in the first chapter, his distance not only from Husserl but also from transcendental phenomenology begins to appear. We recall that for Husserl, the body is bound by its relation with the Earth, such that any conception of an Earth without beings, or beings without an Earth is inconceivable. More than this, the prospect of moving beyond the Earth to alien landscapes proves impossible given the constitutive relation between body and Earth. In his commentary on the Earth fragment, Merleau-Ponty's thinking has moved on from descriptive phenomenology and is now concerned with the ontology of what is revealed in Husserl's thinking (Merleau-Ponty 2002, 73). It is in the conclusion of this commentary that Merleau-Ponty once more turns to the question of the Earth without existents. In Husserl's account, we remain bound to the Earth thanks to the idealizing role of the ego, which makes possible the thought of the depopulated Earth in the first instance. This Cartesianism is inadequate in Merleau-Ponty's late thinking, as he writes of Husserl: "Now the world before man? The world without man if he is destroyed? Death? Answer: all of that diminishes nothing of the constitutive certainties" (75-76). And yet: "There is a paradox only if we first realise... the universe of idealizations" (76). In contrast, Merleau-Ponty makes it clear that his interest is in "the world and... the mind *before* their correlative idealizations" (75. Emphasis added).

This ontological turn marks a rediscovery of the Earth in its originary status. Beyond its status as a relational structure, the Earth retains an autonomy that folds back upon Merleau-Ponty's earlier version of perceptual realism (recall: "*la chose nous ignore, elle repose en soi*"). At the end of this reading, Merleau-Ponty continues to distance himself from both idealism and realism in their classical formulation, labelling them correlations of one another. In their place, a new ontology begins to appear, one that will later present itself in the figure of the flesh. Here, realism and

idealism are turned against each other, from which both orders are revealed as "correlative aspects," not of each other, but "of Being" (76). This ontological turn transforms the Earth from the ground of subjective experience, to an element of Being (or flesh), which is no longer constituted by the ego, but instead prior to the ego and thus to the subject.

Anterior Fossils

The language of an Earth without existents leads us invariably toward the thought of Quentin Meillassoux. Already we have touched upon some of the challenges posited by Meillassoux in the second chapter. There, we sought to employ Levinas as figure who can rupture phenomenology's predisposition to epistemological and ethical anthropomorphism. If we made some progress on this task in terms of dehumanizing the body, then the objective that falls before us now is to situate this anonymous materiality in the context of the cosmos. Meillassoux proves a compelling interlocutor in this respect, as he approaches the critique of phenomenology from the perspective of an issue that is already of concern to us; namely, the Earth before humanity.

This thought begins by establishing the empirical facts: the date of the origin of the universe being 13.5 billion years ago, the date of the origin of life on earth 3.5 billion years ago, and so forth. Such claims appeal to facts anterior to consciousness and thus older than reason itself, yet knowable thanks to a geological analysis—in particular, carbon dating—of artefacts such as fossils. These discoveries, he goes on to say, have enabled science to reach outside of human experience, in order to age the universe itself.

Meillassoux intervenes in this breakthrough by questioning what is it at stake in these findings: "How are we to grasp the *meaning* of scientific statements bearing explicitly upon a manifestation of the world that is posited as anterior to the

emergence of thought and even of life—*posited, that is, as anterior to every form of human relation to the world?"* (9–10). We have traced the outline of this question in chapter two in terms of Meillassoux's notion of correlationism. Now, the structural relation is accompanied by a spatio-temporal dimension, which positions thinking in the realm not simply of deep time but of a time anterior to perspective. To approach this geological thinking, Meillassoux introduces two key terms: "ancestral" and "arche fossil" (10). The terms are simply defined. The former refers to a "reality anterior to the emergence of the human species" whereas the latter marks "materials indicating the existence of an ancestral reality or event; one that is anterior to terrestrial life" (10).

According to Meillassoux, a phenomenological reading of concepts such as ancestrality and arche fossils would accent the relation between the finite subject and the ancestral realm that is apprehended in and through the subject. This gesture restricts metaphysics to another philosophy, and draws a limit as to what thought can investigate. Time and again, Meillassoux pushes phenomenology into an impasse, claiming that the method is incapable of "get[ting] out of our own skin to discover whether it might be possible for such a disincarnation of the correlation to be true" (11).

The relevant part of Meillassoux's thinking for us is less his remarks on primary and secondary qualities, less even his alliance between Cartesianism and science, and more the "codicil of modernity," which, in this thinking, is the inclusion of "for humans" in the approach toward the ancestral realm (13).

It is with this injunction against appropriating the deep past "for humans" that the limits of correlationism are articulated. Against phenomenology, a "literal interpretation of the ancestral statement" would claim that the realist meaning is the absolute meaning, and in effect, that the humanist onus on the relational knot is irrelevant (14). Such a conclusion, so Meillassoux claims,

is unacceptable for the correlationist. It is unacceptable precisely because any such claim about the world before life is a given of the world itself, without which being would not be conceivable except in terms of how it is given (for humans). Phenomenologically, givenness, so Meillassoux suggests, is ontologically primary. In this way, givenness becomes complicit with natural and primordial phenomena. That such things are taken as properties of the physical world only confirms the blind spots which correlationism maintains (15).

The result of this complicity between correlationism and the giveness of being is that ancestral claims only have a relevance by reconstructing the past from the perspective of the finite human in the present. As such, the past in question for the correlationist is in fact a folly or artifice. Throughout, giveness of the phenomenal world reigns supreme, meaning that ancestrality never truly escapes this bind, nor does it position itself temporally prior to givenness: "To understand the fossil, it is necessary to proceed from the present to the past, following a logical order, rather than from the past to the present, following a chronological order" (16).

On this point, Meillassoux claims that correlationism confuses temporal orders by reducing anteriority to simple temporal distance. If notions such as ancient time and deep time retain their place within the phenomenal realm, then the idea of a realm anterior to time breaks this placement: "For the problem of the arche-fossil is not the empirical problem of the birth of living organisms, but the ontological problem of the coming into being of givenness as such" (21). For this reason, correlationism not only remains locked in a relational bind to the world, but also subjects that relation to a spatio-temporal ordering whereby time is reduced to givenness. It is this junction of two different voids—one a constituent of the phenomenal realm, the other beyond phenomenality—that correlationism covertly reverses (22). The correlationist void is one that deceives, for it contains

within itself the means to establish a relation with the ancestral realm, and thereby subjugates this realm to a phenomenology of appearances. The speculative void, on the other hand (evoking Lacan's account of anxiety) is one that never deceives.

Thus, in the face of the question whether the accretion of the Earth happened 4.56 billon years ago, the correlationist is faced with a paradox. On the one hand, from a strictly objective perspective, the correlationist is in a position to answer in the affirmative. Science, verified by a community of other scientists, can attest to such facts. Yet on the other hand, these same facts are only understandable within relation to the scientists themselves. Here, Meillassoux draws attention to an apparent conflation of objective truth and subjective relativity, resulting in a "non-sense" (17). All of which acts as a further foundation for Meillassoux's irremediable realism, which prides itself on having either a realist sense, or no sense at all (17).

At the end of this first chapter on ancestrality, Meillassoux considers a critical objection to his position. The objection concerns a confusion between the empirical and transcendental level: "The empirical question is that of knowing how *bodies* that were organic prior to becoming conscious appeared in an environment which is itself physical. The transcendental question consists in determining how the *science* of this physical emergence of life and consciousness is possible" (22).

At stake in this contrast between the empirical and the transcendental is the conflation of the Kantian or Husserlian subject of knowledge with the actual body that occupies a spatio-temporal world. Unlike the fleshy appearance of the phenomenal body, the transcendental subject of knowledge does not exist, save as an ideal or a set of conditions—a point most obviously associated with a Kantian framework. As such, the transcendental body is not exposed to contingency or finitude, but instead exists as an invariant structure of consciousness.

Clearly, then, there are two orders at work. One, a structural

set of conditions, and the other, a set of phenomenal things which are implicated by those conditions. Of the relation between the two, Meillassoux writes that they are "like two faces of a flat sheet of paper; they are absolutely inseparable but they never intersect" (22). Yet it is precisely their intersection that is being entertained by Meillassoux's fictional interlocutor. The implication of this conflation, according to the critique, is that the non-existent subject of knowledge is reduced to an anthropologized object (23). If correct, this critique transforms the arche-fossil from an ontological problem of anteriority to an empirical problem of depth and distance.

Meillassoux dismisses this objection as ineffective (24). He does so because, while he grants that the transcendental subject is indeed different from the empirical subject, nevertheless "one still has to say that *there is* a transcendental subject, rather than no subject" (24). As such, just as the empirical body is a thing that occupies space and time, so the transcendental subject likewise *"takes place"* and thereby assumes a *"point of view"* (24). In this placement of the transcendental subject through its "incarnation in a body," we can begin to conceptualize the role of the transcendental in the first instance (25).

Here, Meillassoux attempts to reveal to us that the apparent exteriority of phenomenological thought is really an interiority delimiting its own boundaries. If the transcendental subject is a condition for empirical bodies, then empirical bodies are also a condition of the transcendental subject. As such, both aspects fold into one another for the correlationist. Because of this, the temporal relation between these orders collapses: the timeless and non-existent aspect of the transcendental subject of knowledge becomes a localised extension of the body in its empirical existence. To this end, the transcendental reveals itself as incapable of thinking outside of itself.

* * *

Meillassoux's account of arche-fossils and a time of ancestrality illustrates some of the difficulties transcendental thinking faces in relation to *le grand dehors* of a world without humans. While singularly helpful in formulating some tendencies in transcendental thinking, his critique of phenomenology is limited in several respects, all of which can be related to his characterization of the phenomenological subject. For him, the subject of phenomenology is inherited from Kant via Husserl. As such, it (rightly according to this lineage of thought) retains a focus on the transcendental conditions of experience. Because of this, the preservation of a relational knot, which draws all things into a correlation with humans, is retained. As we have seen, such a view leads to a series of inconsistencies for the correlationist, not least the inability to unambiguously respond to ancestral statements. This ambiguity, insufferable for Meillassoux, carries with it a retroactive motion whereby both the transcendental subject and the problem of the arche-fossil are formulated from the privileged perspective of the living subject, a subject incarnated in a finite body. The end result is that transcendental thought never departs from its origins, and instead remains locked in the impasse of a phenomenal realm overly concerned with the limits of knowledge and unable to transgress those limits.

In the remaining part of this chapter, we will construct the groundwork of a phenomenology that can attend to both the alterity of the body and the anteriority of the world. Our method is not to refute Meillassoux's critique point by point, which would be of questionable value, but instead to discover the germs of a new phenomenology receptive to the thing beyond experience and thus constitutive of a horror from within experience. We shall do this by (re)turning to a figure conspicuously absent in Meillassoux's thinking: Merleau-Ponty. We will move beyond the level of the lived body, even when that body is constituted by a temporality outside of experience, as we saw in the previous chapter. There, we shall gravitate toward an

ontology that marks Merleau-Ponty's departure from the Husserlian legacy of transcendental phenomenology and instead moves toward the field of archaeology, geology, and psychoanalysis. The name that demarcates Merleau-Ponty's ontology is *the flesh*.

Toward a Non-Phenomenology

Before us, the task is to extend the unhuman body—a body that both incorporates its origin while also subjecting that origin to its own dismissal—to the Earth and the cosmos more broadly. Once again, we must negotiate the inclusion of a human thinking subject placed on the Earth while also registering the unhuman element that allows the subject to exceed with the Earth. It is in Merleau-Ponty that we can begin to develop this thinking.

Merleau-Ponty's late philosophy is oriented to a move beyond the being/world distinction that marked his earlier phenomenological investigations, to seek therein a pre-world or a wild being which precedes subjectivity and is thus anterior to experience. In some respects, aspects of Merleau-Ponty's early phenomenology, borrowed in large part from Heidegger, are typical of relational (or correlationist) thinking in adjoining "subject" and "world" while preventing there being any gap in-between these terms. What we have in the earlier thinking is a system, whereby being and world are joined as inseparable unit. To be sure, while this union is exposed to several layers of disintegration and resistance—not least, the very experience of horror—nevertheless, the world never entirely slips away from the subject. As we have also seen in this early thinking, in the midst of these phenomenological studies of lived experience, Merleau-Ponty will from time to time occasion upon another side of perception, one that is hostile and silent to experience, and in some sense anterior to space and time. Increasingly as he moves beyond Husserlian phenomenology, this brute or wild being gains a richer and

broader voice, which is conceptualised as an indirect ontology, rather than one that is deduced from lived experience.

For all that, Merleau-Ponty does not dispense with experience, nor with the empirical body. Rather, it is in the midst of experience that what he will conceive a "non-phenomenology," as he puts it in *The Visible and the Invisible*: "The secret of the world we are seeking must necessarily be contained in my contact with it" (Merleau-Ponty 1968, 32). This admission to a contact with the world is not a retreat into correlationism, but instead an interrogation of its limit.

He begins this interrogation by retreading his footprints in and around the thing, writing: "If we try to find out what 'the thing' means for us, we find that it is what rests in itself… that it is by definition 'transcendent,' outside, absolutely foreign to all interiority" (51). Here Merleau-Ponty's earlier confrontation with a perpetual realism begins to take clearer form. Now, the thing is understood in its "indifference, in the night of identity, as pure in-itself" (51–52). This "prereflective zone" leads us "out of our thoughts" and beyond the "phantoms with which philosophy has encumbered it" (52).

The task, then, is to conceptualise a world anterior to thinking and experience, which is nevertheless implicated in thought itself. Already we have seen hints of this attempt to formulate a pre-world in Merleau-Ponty's account of realism and idealism as correlates of the same being. Such a move gathers pace in the latter part of his thinking, where the notion of individuality itself is subsumed by an ontology of elemental existence or wild being. In this context, he will speak of an "ontological vibration," from which a "visibility older than my operations or my acts" is found (123). Into this, the empirical body breaks away from its moorings by way of a "dehiscence" within itself, thereby redirecting itself toward a "mute life [before our experience of the world] has been reduced to a set of manageable, disposable significations" (102).

Likewise, in an essay written during this era, he formally distances himself from Husserl while at the same time establishing an ontology that hinges as much on corporeality as it does "archaeology" (Merleau-Ponty 1964, 165). This geological ontology concerns itself with the "pre-theoretical layer[s] on which [both materialism and idealism] find their relative justification" (165).

Merleau-Ponty's burgeoning ontology removes itself from the concerns of human access to the world and instead positions itself prior to this access. At stake is not the classical notion of intentionality, which indexes a relational bond between act and object, but instead a "latent intentionality like that which animates time, more ancient than the intentionality of *human* acts" (165). This anterior phenomenology, almost entirely overlooked in contemporary critiques of phenomenology, serves to contest the notion that the method is at the service of humanity, and that alone. The phenomenology Merleau-Ponty is developing in these works retains the term "phenomenology" only through the positing of what he will now articulate as a "non-phenomenology" (178). This non-phenomenology is not to be conceived of as something other than phenomenology, but rather as that which constitutes phenomenology in the first instances, as he puts it: "What resists phenomenology within us—natural being, the 'barbarous' source Schelling spoke of—cannot remain outside phenomenology and should have its place within it" (178). Indeed, it is with Merleau-Ponty's late turn to Schelling that the framework of an elemental ontology becomes clear.

A Tenebrous Phenomenology

What Merleau-Ponty finds in Schelling is a precursor to the elemental ontology that will play a central role in the former's late thinking. The term "barbarous" is important here, given the

etymological link between the Latin *barbaria* as referring to a "foreign country" and the Greek *barbaros* referring to that which is strange. In this early incarnation, the pejorative sense of "barbarian" was absent. The association with uncultivated or rude comportment only arrives in the seventeenth century.

This earlier sense of the term, accenting the strange and foreign is the context in which Schelling's concept of abyssal time finds its place. In Schelling, the voice of a time anterior to time emerges. It is from this temporal depth that Merleau-Ponty's ontology articulates itself as a shadow of this thinking. Indeed, to understand Merleau-Ponty's non-phenomenology—itself a variant of realism—we need to understand the relation this thinking has to Schelling, especially the Schelling of *The Ages of the World*, which documents the nature of creation and the importance of the "barbaric principle," which Merleau-Ponty cites throughout his thinking on ontology (Merleau-Ponty 2003; Schelling 1997). As Merleau-Ponty turns away from Husserl, and from classical phenomenology more broadly, so the presence of Schelling as a precursor to Merleau-Ponty's phenomenology becomes increasingly evident.

Schelling begins his *The Ages of the World* with an account of the nature of the past. The task, as Schelling conceives it, is to return to the "first or oldest of essences" (Schelling 1997, 113). To do this, what is required is not simply a historical analysis of the formation of certain narratives, all of which would be contained with a human sphere. As he writes on objective history: "These monuments of nature lie for the most part out in the open; they are thoroughly researched, in part genuinely deciphered, and yet they tell us nothing but rather remain dead until that succession of actions and productions has become inward" (116).

This, according to Schelling, has been the hindrance of modern philosophy: its limitation within content and its lack of attention to the very form of time. To understand the origins of time, "Man must be granted an essence outside and above the

world" (114). In this way, the origin of the time—time itself—is not sublated into an unfolding Hegelian pathway, but is instead marked as a zone of endurance, never integrated and therefore never localised. More than this, the ground of nature is "eternally obscure," described elsewhere as "insane" and "nocturnal" and even the "night of chaos and unreason" (Schelling 1859, 337).

How to approach this nocturnal ground? Schelling turns to the human being. There, he finds the resources to commune with an original past, writing that:

He alone, of all creatures, [could] retrace the long path of developments from the present back into the deepest night of the past, how could he alone rise up to the beginning of things unless there were in him an essence from the beginning of times? Drawn from the source of things and akin to it... (Schelling 1997, 114).

We have in this passage a confirmation of the anteriority of the body, a body that we have been plotting through this book in the figure of an unhuman manifestation. The body's duplicity is revealed as that which belongs to the present as the site of lived experience, while at the same time tearing itself from the fabric of the present in its reach into the "deepest night of the past," from whence it finds itself not simply a witness to the origins of things, but as a fundamental element in this origin. The slumbering past that sleeps within the body awakens in Schelling's thought, and thereby finds itself as both the voice of "the most ancient past as well as the most distant future" (114).

This temporal shifting body, which anticipates the Lovecraftian entity we discovered in the previous chapter, is nevertheless "essentially mute and cannot express what is enclosed within it" (114). It is precisely because of this silence that the prehistory of things is retained rather than being

rendered transparent to the gaze of the subject, and thus humanised. Throughout this prehistory, the body is not the ambassador of the past, but instead its blind voice, "an inner oracle, the only witness from a time before world" (114). We are not in the realm of time travel, where such travel masks itself as the surveying of distant worlds and fallen empires. Rather, the time of the abyssal past is outside of history, and its expression is the silent and brute world of matter itself.

The body thus becomes the particular expression of the genesis of time, a point that Merleau-Ponty was already contending with even in his early phenomenological studies of Cézanne. The origin remains at the centre of things, silently buried beneath the appearance of the world, and yet at all times, growing, developing, and waiting patiently. At times, the past of all pasts resurfaces, finding within it an "instrument in which it could behold itself, express itself, and become intelligible to itself" (115). Here, Schelling will speak of a "doubling of ourselves," as these two realms of time intersect, rendering the outer or personal layer a "shadow" of time itself (115).

From Schelling's concept of a primordial abyss, Merleau-Ponty finds the necessary ingredients for his own elemental ontology. Thus, in the lectures on nature, he introduces Schelling's philosophy of nature by accenting *"erste Natur"* (first nature) as the central theme, writing that:

This *erste Natur* is the most ancient element, "an abyss of the past"... *Erste Natur* is "the fundamental stuff of all life and of every existing being, something terrifying, a barbaric principle that one can overcome, but never put aside" (Merleau-Ponty 2003, 38).[8]

In all this, Merleau-Ponty turns to Schelling to develop an ontology which is freed of its appeal to humanity. In each thinker, nature is precisely the domain that is prior to subjectivity and

reflection. As Merleau-Ponty argues, to understand nature, it is not a question of enforcing an idealised, Kantian framework upon raw matter. Rather, this idealised framework needs to be inverted and deformed, meaning that "what we call the I and what we call a living being have a common root in pre-objective Being" (40). At the same time, this gesture does not mean implanting a vitalism in the inorganic realm, less still a pantheism or a nature guided by teleology, in which all-is-one by dint of a pre-established harmony in the cosmos. Rather, to develop a "phenomenology of prereflexive Being," as Schelling (and Merleau-Ponty) are doing, is to recognise the "terrible" darkness that lurks within all things (41).

The darkening of this phenomenology stands in contrast to the Enlightenment philosophies that seek to shed light on nature by the power of reason. What we find, by contrast, in Merleau-Ponty and Schelling, is that nature casts shadows upon the spectator, obscuring the view that would otherwise be presented as a source of illumination. If we can speak, as Schelling would, of a "terrible" phenomenology, then let us also in this spirit talk of a *tenebrous phenomenology*—a phenomenology that finds its strength in the "amorphous necrophagous shadows [that] dance beneath an accursed waning moon" (Lovecraft 2008, 14). Such a phenomenology would be receptive to the primordial aspect of nature, not as a source of renewal for humanity, but as the site of an invasive shadow, which threatens at all times to decentre and deform humanity.

The shadowline of a tenebrous phenomenology finds another face in the early thinking of Levinas and his treatment of aesthetics. As we have seen in the second chapter, Levinas assigns a nocturnal status to thinking that reveals itself above all in the figure of the *il y a*. This zone of anonymity is manifest elsewhere in his account of the aesthetics of shadows (Levinas 1989). In the early essay, "Reality and its Shadow," Levinas presents to us an anti-aesthetics, which runs counter to the

tradition of aligning the work of art with a realm beyond experience, and thus bestowed with the power of illuminating our sedimented orientation toward the world. In fact, it is precisely the darkening of the world that art gives to us, rather than the act of enlightening. Confronted with a statue, what we witness is not matter coming into life, but matter as fundamentally caught behind, "eternally suspended" and thus resembling the temporality of a "nightmare" (138–139). As with the characters in a novel, objects of art are imprisoned in a void of time, committed therein to the "infinite repetition of the same acts" within the "hither side" of time itself (139). In this way, death is never quite dead enough in the work of art, as he writes: "In dying, the horizon of the future is given, but the future as a promise of a new present is refused; one is in the interval, forever an interval… This is the anxiety which in other tales is prolonged like a fear of being buried alive" (140–141). Within this interval of anxiety, art emerges as the voice of "something inhuman and monstrous," a rupture in our experience of temporality, which is now marked, less by the celebrated clearing in Heidegger and more by the invasion of shadows from Levinas (141).

If humanity enters the sphere of the shadow, seeking to reveal it as a prism of light, then such gestures can only be understood retroactively, given that the darkness has already implanted itself in the power of reason long before reason's self-assertion. This revelation of light as constituted by darkness is peculiar to human subjectivity. It is through the organ of human subjectivity that the darkness of nature—the eternal night—articulates itself as a resistance and a struggle. The struggle is situated at the intersection of the body as the vehicle of expression and the body as, in Merleau-Ponty's terms, "the recapitulation and the contemporary of creation" (44). If we follow Schelling in pursing the Absolute as the endless night, then we would find ourselves "lost in a concentrated and indivisible time, which would make me lose all my I" (45). In the face of this tenebrous ontology, the

human subject pulls back from the brink of darkness, preserving what strength it has in order to invest it in the light that remains. This gesture of light turning inwards only to find a darkness that resists scrutiny is a theme that binds Merleau-Ponty and Schelling at the very grounds of their thinking. In each philosopher, the task of thinking is to formulate an indirect ontology, which is at home in the shadows. For it is in the shadows that we are best placed to catch sight of nature, *without us*.

The Thing and the Flesh

For Merleau-Ponty and Schelling, nature is a primordial ground, but also that which can never be integrated into experience. Instead, nature signals an excessive matter in the world, without which "the world would already actually be dissolved into nothing" (Schelling 1942, 229–230). As we have seen, the wild being that nature belongs to assumes the name of a "barbaric principle" in Schelling, a term Merleau-Ponty adopts. For both thinkers, nature is not the opportunity for a subject to consolidate and reinstate their subjectivity. Nature is not, in other words, an event of the sublime. Indeed, it is precisely because nature is anterior to space and time that it resists the lineage of romantic aesthetics, as one would find in Kant and Schopenhauer. Because we are no longer in the region of sublime, nature is no longer that which is positioned on the horizon of consciousness, against which the subject is afforded a detached perspective. Instead, nature is the living ground of being in all its fleshy articulations—of us, yet at the same time, without us.

This elemental or tenebrous ontology resurfaces elsewhere in Merleau-Ponty's late thinking on psychoanalysis. As with his account of nature, what Merleau-Ponty is seeking in turning to psychoanalysis is to conceptualize the unconscious "as an

archaic or primordial consciousness, the repressed as a zone of experience that we have not integrated, the body as a sort of natural or innate complex" (Merleau-Ponty 1994, 67). Such a psychoanalysis would not be concerned with the archaeology of the intra-psychic conscious, less still the restoration of the ego as one would find in a humanistic psychoanalysis. Rather, the analysis proceeds by way of ruptures, invasions, and interruptions, all of which are deployed to destabilise the centrality of the subject as an autonomous or rational entity.

Merleau-Ponty's foray into psychoanalysis finds its roots in the primordial zones of emergence outlined in Schelling's philosophy. Indeed, it is in this writing on psychoanalysis that Merleau-Ponty again turns back to Schelling, referring once more to the "barbarian in us," led at all times by a "phenomenology which descends into its own substratum" (70). Such a psychoanalysis would find its strength in returning to the pre-human origin that establishes itself as the real within the psyche. This archaeological movement conjoins phenomenology and psychoanalysis into the "same latency" through contending with "that *intemporal*, that *indestructible* element in us" (71). The term Merleau-Ponty gives to this intemporal and indestructible element is "the flesh" (Merleau-Ponty 1968).

The flesh enters his thinking by way of a return to the critical question he posed in the *Phenomenology of Perception*: How is it that I can perceive a thing while that same thing also resists my experience, apparently withdrawing itself? Famously, the question is directed toward the example of one hand touching another. The example is important as it complexifies a series of boundaries, between the perceiver and the perceived, the sensible and the sentient. Thus, in the illustration, interiority and exteriority "incorporate themselves into the same universe they interrogate, are recorded on the same map" (133). With this thought, Merleau-Ponty begins to conceptualise the notion that every visible thing is "encrusted" into the same element.

Moreover, because material things are composed of this primordial element, "he who sees cannot possess the visible unless he is possessed by it, unless he *is of it*" (134–135). What Merleau-Ponty is beginning to do here is trace the outline of a new ontology that will allow him to formulate the existence of things in the world without reducing those things to the level of empirical appearance. Such a move is already evident in his notes on nature. Thus from the perspective of a primordial ontology, the

> Universe... is a primordial universe. The universe of theory subtends an already present universe. Behind this world, there is a more originary world, anterior to all activity, "world before a thesis": the perceived world. Whereas the first is given as a constructed world, the perceived world is given itself in flesh and blood (Merleau-Ponty 2003, 73).

This conversion of the universe into flesh is possible because the thing itself is made of the same stuff, as he puts it: "It is that the thickness of flesh between the seer and the thing is constitutive for the thing of its visibility as for the seer of his corporeity" (Merleau-Ponty 1968, 135). In other words, it is with the term "flesh" that Merleau-Ponty designates an element anterior to experience yet at the same time implicated in experience, not least the human body, which, for Merleau-Ponty retains its exemplary status.

The body, as it plays a role in this thinking, shifts from the level of experience to an artefact of ontology, marked by its own "ontogenesis" (136). Thus, the usage of the term "flesh," far from an extension of the flesh of the empirical body, in fact refers to the "presentation of a certain absence... of which our body, the sensible sentient, is a very remarkable variation" (136). That the body is a variation of the flesh means, therefore, that the flesh is not reducible to the body, but instead immanent in all things. For

this reason, Merleau-Ponty speaks of himself as being "looked at by the things," and "to be seen by the outside… alienated by the phantom" (139). This depiction of interiority and exteriority folding into the space in-between—what Merleau-Ponty will describe as the *écart*—establishes a strange ontology, in which the human body is less the expression of human subjectivity and more a manifestation of a brute flesh.

To bring the flesh into conceptual clarity, Merleau-Ponty declares what the flesh is not. It is not, in the first instance, matter, mind or substance. Rather, in order to articulate it, "we should need the old term 'element'" (139). The flesh is an element in that it marks an "ultimate notion," no longer divisible into being and world. Because it is elemental and prior to perception and subjectivity, it lacks all experiential facets and can only be approached as an anonymous zone that silently inhabits things. The flesh is mute existence, thinkable only in terms of a depth rather than a horizon of experience. In this way, it marks a union with the unconscious, as that which structures things while also retaining an autonomy from those things.

How, then, to think of the flesh? Merleau-Ponty redirects us to the body. The flesh that he speaks of in regard to the body is not that of flesh and blood, as it is commonly understood. To say that all things are made of the flesh does not mean that all things are made of the same corporeal substance as the body. At the same time, when speaking of the flesh, the carnality of the body is in some sense a privileged matter. But the ontology of the flesh extends beyond that of the body. Above all, its meaning can be attributed to the strange intertwining or kinship between different things. The strangeness of this ontology is that it avoids falling into a Heraclitean account of unity within difference, but instead manages to preserve that difference in an elemental way. The flesh does this because the difference in question is not the phenomenal difference of particular things, but the "differentia-tions of one sole and massive adhesion to Being [Nature] which

is the flesh" (270). At stake, then, is a difference prior to a phenomenology of difference. In this way, we can speak of this elemental difference in Merleau-Ponty as an *in-difference* (cf. Vallier 2009, 130).

It is with this sense of the flesh as an in-different element that the role of the subject is undermined by a reality defined only through its structural negativity. Of the flesh, there is nothing that can be said, as to name it would be to insert it into the world of particular things. In revealing itself here, it also conceals itself in the shadows, which, as Merleau-Ponty will say in his late essay on Husserl, is where "the perceived world endures... through the reflections, shadows, levels, and horizons between things" (Merleau-Ponty 1964b, 160). To speak of the "flesh" is thus to speak of an analogy of the thing. This "connective tissue" marks the point at which things come into being (Merleau-Ponty 1968, 132). But if there is a relationship between the being of things and the thing itself—the flesh—then such a relation is not the harmonious correspondence often associated with phenomenology, as Merleau-Ponty has it in the lectures on nature: "Nature in us must have some relation to Nature outside of us; moreover, Nature outside of us must be revealed to us as the Nature that we are" (Merleau-Ponty 2003, 267). This reversibility structured by the flesh is not, therefore, a fusion of sameness and difference, but the precise point at which the interiority of the subject gains its structure through a relation with that which lies beyond the subject.

More than this, the flesh has no ethics, less even a teleology to guide us back to the origin. The flesh is outside of history, outside of space, signalling what Merleau-Ponty calls (with Schelling in mind), a "transcendental geology" (Merleau-Ponty 1968, 258). The term comes in an especially dense note from the final unfinished manuscript. Yet from it, the vision of the flesh in its in-difference to phenomena can be gauged indirectly.

Merleau-Ponty introduces the idea of transcendental geology

by contrasting it with a philosophy of history, as one would find in Sartre. Such a philosophy would concern the narrative of a particular history taken from the perspective of an "individual praxis" (258). At the same time, this rejection of a philosophy of history leads to a "philosophy of geography," which, foreshadowing the development of phenomenological geography and architecture, would confine itself to space as the "relation between persons" (258). Against this, Merleau-Ponty posits a thinking that, while grounded in geography, must orient itself toward a "transcendental geology," which is capable of conceptualising the "very time that is space, this very space that is time" (259). This is the spatio-temporality of brute in-difference, which allows for the existence of a "historical landscape and a quasi-geographical inscription of history" in the first instance" (259).

The note reveals the final paths Merleau-Ponty's thought was taking before that thought was interrupted by his untimely death. We see here the sketch of an applied analysis of the flesh to a particular structure of ontology; namely, the very ground of Being as flesh. Merleau-Ponty's geology-as-flesh model of Being leaves the Earth not only unknown but also fundamentally unknowable. Beyond the level of time and space—even that of the Earth in relation to the body—a geological stratum, irreducible to the geology of ancient caves and Martian canyons, undercuts any relational ontology by positioning the real outside of thought itself. The inclusion of "transcendental" in this geology indexes Merleau-Ponty's final move beyond the body to an ontology that no longer depends on the expression of the body. In place of the body, we find a geology of the flesh that exceeds the ultimate primordial foundation, thus marking the intersection where both origin and extinction coincide in their reversibility.

<p style="text-align:center">* * *</p>

Even at the level of a provisional analysis, the implications of Merleau-Ponty's theories are far-reaching, and extend well beyond the level of Husserlian phenomenology characterised by Meillassoux in his critique of correlationism. In the first instance, the notion of flesh is inconceivable within the scene of classical phenomenology, and thus correlationism. The reason, is that flesh is neither an object of intentionality nor an act of intentionality. Nor is it defined by its relation to things, such as being and world. The flesh does not depend on its corporeality, less even an experiential dimension. Indeed, the flesh has no experiential dimension, save that of the hostile silence that Merleau-Ponty spoke of earlier in his thinking. Furthermore, the flesh is an element in that it possesses things but can never be possessed by those things. Thus the flesh is without a face, a mute concept, non-existent as a particular thing but instead suffused through things as a primordial depth, which, in its anonymity, recalls the Levinasian idea of the *il y a*. In distinction to Levinas's concept, for Merleau-Ponty this anonymous, faceless element reaches beyond the night of insomnia and instead signals itself as the elementality of the universe.

* * *

As we recall from Meillassoux, the fundamental limit of correlationism is that it cannot conceive of anteriority except in relation to the questioner. What this means is that the notion of a world without humans—the topic of this chapter—is a retroactive notion, one that is deduced from the standpoint of the present. Phenomenology, true to its commitment to describing the relation between the subject and the world, fails to move beyond the givenness of phenomena and instead deceitfully imparts that structure of givenness to that which purportedly lies beyond description—be it death, nameless horrors, or an alien intelligence other than our own. In each case, the thing that should not

be masks itself as an appearance for phenomenology to apprehend, and in this respect, distorts the very anteriority of the ancestral realm.

Yet as we have seen, this account of phenomenology as forging a series of phenomenal points in the midst of non-phenomena is at odds with Merleau-Ponty's variant of phenomenology. For him, as for us, a darkened phenomenology marks the intersection whereby the conceptual language of archaeology and geology assume a much greater significance than that of lived experience. Indeed, the very question of experience loses its bearings in this philosophy, as the concern shifts from that of the subject/world distinction to that of how thought can conceptualize the pre-theoretical levels on which thinking itself takes place.

As for the body that remains, now, the archaeology of the thing inverts the body from a site of lived experience to a "trace," in that it marks "a survival of the past, an enjambment. The trace and the fossil… " (Merleau-Ponty 2003, 276). This fossilizing of the body strips materiality of its hold on the present, and imbues that present with the image of an "ammonite" (276). This reconversion of the body to an extinct life—a life that finds its origins in the ancient seas of the Earth, extinguished by a meteorite collision some 145 million years ago—means that the appearance of the body is also the disappearance of the subject. What survives the depth of time is not the culmination of reason or the apotheosis of spirit, but a spectral materiality, as Merleau-Ponty has it: "the living thing is no longer there but it is almost there; we have the negative of it" (276).

Finally, the work of phenomenology becomes mute like that of a zone delineating a concept with no thinker, or a body with no subjectivity. If such a zone constitutes "nature," then it is a nature fundamentally resistant to our reflection. For these reasons, the flesh of the thing is not an invitation for the human subject to renew their relation to the world, less even to cultivate a specious

environmental ethics in the face of a desecrated world. Whatever merits such projects entail, they find no grounding in Merleau-Ponty's ontology. Rather, his ontology points to the very limit at which traditional philosophy fails, not into a mystical Wittgensteinian or Schopenhauerian silence, but into an uncanny silence marked by what Schelling termed the "abyss of the past," which is fundamentally indifferent to human subjectivity and yet, in Merleau-Ponty's formulation, "always remains present in us and in all things" (Merleau-Ponty 2003, 38).

* * *

Before subjectivity, before humanity, another origin anterior to experience emerges. Formless, the flesh of the thing embeds itself in the brute world, against which a philosophy of descriptions undergoes a loss of orientation and thereby finds itself in the midst of its alienage. Nowhere is this alien resistance clearer than in the materiality of the body, as much an organ of perception in the present moment as a prehistory unknowable except as the trace left behind. As this body withdraws from experience, so it produces an excess in the world, which must now be approached from beneath matter, or rather, *from beyond* matter. Devoid of subjectivity, devoid of experience, silence intervenes. In this zone, the indifference of the flesh gives birth to the thing. The thing has no identity, except that of a constantly mutating process, barren of all specificity and instead able insidiously to adapt itself to its surroundings. Of it, we can say only that *there is a thing*. The thing is there, present but only as a field of anonymity. Into this murmur of an indifferent cosmos, Merleau-Ponty positions us on the verge of thing and flesh:

> The thing thus defined is not the thing of our experience, it is the image we obtain of it by projecting it into a universe where experience would not settle on anything, where the

spectator would abandon the spectacle—in short, by confronting it with the possibility of nothingness (162).

And there, in the abyss of a universe without a spectator, the thing remains.

The Thing

The very moment when the earth becomes for the second time desolate and empty becomes the moment of birth for the higher light of the spirit that was in the world from the very beginning, but not comprehended by the darkness acting for itself... and, in order to counter personal and spiritual evil, the light of the spirit in fact appears likewise in the shape of a human person.

F. W. J. Schelling, *Philosophical Investigations into the Essence of Human Freedom.*

I

It begins in the darkness. Stars punctuate the void, and from the depths, a spaceship comes into view. As it passes us by, it veers off toward the Earth where it disappears into the atmosphere. And then there is nothing but a slowly pulsating heartbeat: repetitious, ominous—the sound of things coming into existence. We are now in Antarctica during the winter of 1982. An image of a landscape made desolate by snow. An isolated research station, Outpost 31, breaks the monotony of the white horizon. A team of scientists are at work in various installations and laboratories constructed at the institute. There, they are joined by a stray dog, rescued after being pursued by a lone Norwegian helicopter pilot. Quite why the pilot was possessed with the urge to shoot the animal, we do not yet know. Sent out to establish what drove the pilot to this state, the team study the Norwegian camp. As they do, the camera returns to the quiet interior of Outpost 31. We are shown a series of empty rooms, each of which is revealed to us slowly and deliberately. A medical bay, a recreational room,

a corridor with an open door to the left. At the top of the corridor, the dog tentatively creeps into view, before working its way down the corridor. At the tip of the hallway, the lone dog joins one of the researchers in an adjoining room, whose identity is revealed only as a shadow.

II

We have been placed on the Earth's surface. On it, we are protected by the thin atmosphere which insulates us from the space beyond the horizon of the planet. As it cradles us, we become attached to the materiality of our surroundings, inscribing within it an entire homeworld. But there is restlessness as well as repose. Over time, we found a way to escape from the Earth by way of artificial machines. As we have done this, a new view of the planet has emerged. Prior to the image of the Earth as a blue orb in the night's sky—a view first captured on December 7, 1972 by the crew of Apollo 17—we were forced to rely on the testimony of Yuri Gagarin's description of the Earth from space as being surrounded by a beautiful halo. Having left the Earth's atmosphere, Gagarin's body became imbued with a special sort of significance. In the words of Levinas, the significance is marked by the fact that "he left the Place. For one hour, man existed beyond any horizon – everything around him was sky or, more exactly, everything was geometrical space. A man existed in the absolute of homogeneous space" (Levinas 1990, 233). Gagarin's return to the Earth was not without its complications, however. Back on Earth, his first contact with outer space rendered him a strange kind of celebrity. Unable to reconcile life on Earth with the vision captured on board Vostok 1, he fell into a state of melancholia. What astonishes Levinas about Gagarin's journey is "the probable opening up of new forms of knowledge and new technological possibilities" (233). This opening of knowledge is not simply to be found in the mechanics of space. Rather, their

source is the body of Gagarin himself. In his flight into space, Gagarin carried with him a knowledge that is irreducible to objective knowledge or quantifiable data. His is a knowledge that goes beyond the Earth, is resistant to Earth's re-entry, and thus remains hovering both in the margins of outer space and in the crevices of his body.[9]

III

The Norwegian camp is burnt to the ground; smoke is still emerging from the ruins, and fragments of charred wood are buried in the snow. Two men from Outpost 31 — Mac and Doc — enter the site. A red axe is stuck in a door, while patches of blood have become frozen around the centre. They venture in to find the dead body of a Norwegian scientist stationary in his chair. His neck has been sliced, and icicles of blood descend from his arms. In a backroom at the laboratory, the men find what looks like a tomb made from snow. Doc remarks: "Maybe they found a fossil, the remains of some animal buried in the ice, and they chopped it out." An omen has been deposited outside of the camp. As the men expose themselves to the cold, they discover the corpse of a deformed body in the snow, its limbs skewed and its flesh burnt.

IV

Despite our best attempts at envisioning the Earth from afar, the planet nevertheless resists our interrogation on both a conceptual and experiential level. Something in it refuses to assuage the human desire for homeliness. Against Husserl, the thing constantly moves beneath our feet. If the Earth is knowable, then it is only because it draws a limit against what cannot be known. Within the cities and forests etched on the surface of the planet, the irreducible element persists blindly,

revealing itself in moments of anxiety and horror, especially those in the twilight. For Levinas, the time before the Earth is "mythical," as it marks the reign of "mythical gods" (Levinas 1969, 142). In the face of these entities, we "run up against the very strangeness of the earth" (142). Strange because the elemental Earth marks a "way of existing... outside of being and the world" (142).

V

The Norwegian corpse is returned to Outpost 31 in order for an autopsy to be performed. The corpse is even more abject than when resting in the snow, where it was at least afforded the illusion of being reclaimed by a benevolent nature. Now the extent of its deformations are viscerally clear. The limbs of the corpse seems to be suffering some kind of cancerous tumours, which, in the process of reconfiguring themselves, have produced massive claw-like protrusions. Other limbs are contorted, as though grimacing in agony. The head—insofar as it is still a head—appears to have produced a double of its own image. Now, the face is coming apart, but instead of fragmenting, it has become elasticised by a gnawing mouth, which joins together two sets of eyes and two noses. Despite all this, the organs remain human. Nothing internal has changed, other than a reconfiguration of the parts of the body. The camera pans down and reveals that the dog is witnessing the whole scene.

VI

Beyond appearance, phenomenology contends with another body, one that is also evident in the image of a corpse. Faced with the death of the body, an autopsy becomes an impasse. Part of this limitation is an inherent bias toward the phenomenology of experience. Against Descartes, we tend to impose a unity on the

body, which forces the parts of the body to cohere in relation to the whole. Remove a body part, and what remains is an organ, as alien as the other side of the cosmos. But this does not mean that lived experience brings these organs back to life, as Deleuze correctly claims: "But the lived body is still a paltry thing in comparison with a more profound and almost unlivable Power" (Deleuze 2005, 44). In the redefinition of phenomenology as unhuman, the body finds its source material neither in the vitalism of lived experience nor in the objective analysis of the body as a set of parts. Rather, to speak of a phenomenology of the body is to speak of foreign matter, alien tissue, archaeological space—all of which, in its brute elementality, is autonomous from the classical concept of identity that places a sanction on the independence of the flesh.

VII

The transformation of human flesh has been extended to that of animals. In a cage, the dog is beginning its violent rebirth. As was the fate of the Norwegian, the dog's face is fragmenting. Where a face should be, we are now confronted with the interior of the flesh, the sides of the face peeled back like an over-ripened fruit. As its face disappears, tentacles sprout aggressively from the dog's back. Within a moment, the tentacles themselves transform into a set of insect legs. Little remains of the original dog, save its coat, which is now bloodied by its mutilation. Hearing the commotion of flesh revealing itself, the men investigate: "I don't know what the hell's in there," remarks one of the team, "but it's weird and pissed off, whatever it is." Mac opens the gate, and the dog gazes toward the flashlight. It has become a gelatinous mass with no discernable form. Here, the claw of a dog, there the blinking eye of a human. Indeed, the thing is less a creature and more a composite of different lifeforms arbitrarily bound by being constituted from the same elemental stuff: *flesh*.

VIII

"There is," so Lacan writes, "a horrendous discovery here, that of the flesh one never sees, the foundation of things, the other side of the head, of the face, the secretory glands *par excellence*, the flesh from which everything exudes, at the very heart of the mystery, the flesh in as much as it is suffering, is formless, in as much as form in itself is something which provokes anxiety. Spectre of anxiety, identification of anxiety, the final revelation of *you are this—You are this, which is so far from you, this which is the ultimate formlessness*" (Lacan 1991, 154–155). On the other side of the body, the phenomenon of anxiety dwells. This close proximity between horror and anxiety is not contingent, but instead operates as a reversal of the same object. If horror is the image of abjection, then anxiety, as Lacan intimates, is the recognition that the horror is already there, within the flesh and thus the subject. Such horror is seated in the independence of the body. Beyond the subject, the life of the body comes to fruition largely through its own betrayal, as Schelling writes: "An individual body part, like the eye, is only possible within the whole of an organism; nonetheless, it has its own life for itself, indeed, its own kind of freedom, which it obviously proves through the disease of which it is capable" (Schelling 2006, 18). Precisely in the body's insurgency its vitality is restored, even at the expense of defacing the subject.

IX

The team are gaining insight into the nature of the thing. Dissecting the mound of dead matter, the mortician in the group, Doc, begins his diagnosis: "You see what we're talking about here is an organism that imitates other life-forms, and it imitates them perfectly." Lacking a substance of its own, much less a discernible appearance, the thing doesn't simply duplicate other life-forms,

but actively negates them as it begins the process of assimilation. Doc points to the corpse, singling out the dislocated head of the dog that peers from beyond the bloodied bones: "This for instance, that's not a dog. It's imitation. We got to it before it had time to finish."

X

Our identities are precious, and safeguarding our subjectivity begins with the limits of our bodies. Confronted with a doppelgänger, we tend to react, not with the narcissism suggested by encountering our mirror image, but with horror at the implication that our subjectivity has been duplicated and therefore deformed. The singularity of our bodies is irreducible. When recognising that our organic identities are anonymous, we repress the thought. But this repression of the facelessness of the body is tenuous, and our existence is predicated on a careful balance, recognising the parts of the body as mute organs and ascribing to those organs a voice. Before affectivity, however, there is Artaud's body without organs, to which Deleuze ultimately gives a voice via the visual image of Francis Bacon. At stake in this vision is a "neutralized organism," in which, "the human visage has not yet found its face" (Deleuze 2005, 46). This is the body as we find it in its ugly emergence, caught between states, as an interstitial corporeality where language lacks the means to organise materiality into a whole. "The primordial being," as Merleau-Ponty describes it accurately, "which is *not yet* the being-subject *nor* the being-object... " (Merleau-Ponty 1970, 65–66). It is horrifying and horrific not because of its alienness, but because we are already at the scene of anxiety, caught up in that formless flesh which is not a passive backdrop against which real life takes place, but is precisely the site where life is composed and duplicated.[10]

XI

The team of Outpost 31 have arrived at a dig site, the location where the Norwegians had spent much of their time. A massive recess in the land reveals the buried remains of the rotating craft witnessed in the first scene. Its wingspan is immense, effectively reforming the landscape as it made its turbulent descent from space. The main structure is now covered in snow, yet the outlines of the vessel are clearly evident in the landscape. The three men stand before the ruin, inadvertently recreating a silhouette typical of the paintings of Caspar David Friedrich. Only in distinction to the sublime aesthetics of the "Wanderer in a Sea of Fog," the vision we are now presented with lacks the confidence that reason will ultimately tame the wilderness of an alien environment. The men make their way down the banks of the incline. Examining the wreckage, they estimate that the structure has been buried in ice for at least 100,000 years. Just beyond the dig site, the excavated tomb has left another absence in the landscape. Far from consigned to its death, the unearthed tomb carries with it the promise of a new origin.

XII

We have returned to the Earth as a planetary void. The blue orb figures as a recess in the cosmos, which, in its buried secrets, ejects humanity from the soil. The Earth will perish. Burnt out by the sun, the planet's death will mark the end of thinking itself, as Lyotard has it: "In 4.5 billion years there will arrive the demise of your phenomenology and your utopian politics, and there'll be no one there to toll the death knell or hear it" (Lyotard 1991, 9). But the anteriority of the Earth is not confined to the future. Rather, the limit is implicated in its history. The disappearance of the Earth is one way in which thought is expelled from the body. Already the erasure of a horizon exists as the spectral afterlife of

the prehistory of the Earth. Like Hegel's owl of Minerva, we turn to an Earth that has come into the cosmos too late. Already it is conceived from its inverse image, and thereby marks a death manifest in the anteriority of a dusty planet composed from the scattered remnants of the cosmos, both organic and non-organic. It is no longer the origin of something, but the continuation of a history that finds its source in a solar apocalypse, of which we are the resultant shadow.

XIII

The human dimension of the horror has entered the scene in the form of escalating paranoia. The suspicion of the Other as other is germinating in the flesh of the men. A notebook is found: "There is still cellular activity in these buried remains. They're not dead yet." Worse than this, a calculation is made: "Probability that one or more team members may be infected by intruder organism: 75%. Projection: If intruder organism reaches civilized world areas... Entire world population infected 27,000 hours from first contact." These apocalyptic insights are broken by a scene of pure abjection, where one of the research members interrupts another member midway through his assimilation by the thing. The torso of the taken body is naked and covered in blood. On his face, an expression of mute resignation is offset by the tentacles that are now sliding their way over and into his body. The unhuman creature runs into the snow. Frozen with panic, he slumps on the floor. As the men surround him, the thing turns to them. As it does, the creature reveals a set of malignant claws where the hands used to be. It exhales an inchoate scream before the others burn it alive.

XIV

Faced with the end, faced with the apocalypse, the past folds

over into the future. In the process, time collapses, and the hour of ghouls, revenants, and unhuman bodies emerge. In response, the human body prepares for its own passing, either through an affirmation of brute survival or through a rationalization of things to come. The terraformation of planets other than our own assumes an equal importance with the arrangement of one's paperwork on Earth. Yet throughout all this, the end never actually comes, instead forming a protracted coda, in which death itself becomes ambiguous while the body as a living organ persists through the end. As Schopenhauer reminds us, the brain, far from essential to life, is merely an addition, "as in the cases of brainless abortions, and of tortoises that still live for three weeks after their heads have been cut off; only the *medulla oblongata*, as the organ of respiration, must be spared" (Schopenhauer 1966, 246–247). After the subject, the body will go on. As it does, the body undergoes a process of transformation, losing none of its original vitality. That the identity of the subject has been mutilated by its assimilation to things outside of experience means nothing for the body as brute being. All that is revealed in this end is a layer of persistence, which, lying beneath the veneer of subjectivity, will outlast the life it once attached itself to on a transient level.

XV

The men are infected. The thing is speeding, and society is breaking down. Human trust itself has become infected with the thing, and the body has become a site of suspicion that can only be verified through blood tests. In a preemptive measure against possible outbreak, some of the men have been tied to a sofa, as if waiting to be processed. Others have retreated into unconsciousness, apparently too exhausted to endure. At the height of this social tension, we are returned once more to the horror of the body. One of the unconscious men—a secondary character

named Norris—is on an operating table, as Doc attempts to revive him with a defibrillator. As he presses down with the apparatus on the man's stomach, the flesh opens up, revealing a set of claws on the walls of the stomach. The teeth quickly fix upon Doc's arms, amputating him instantly. From the opening in the stomach, the thing reveals itself in yet another fleshy guise. This time, its manifestation is a more complex, and therefore more repellent figuration. The head of Norris reappears, only now grossly disfigured, with an elongated neck emerging from a deformed base. The camera pans back, allowing the viewer to witness the thing's emergence against the backdrop of the room. The contrast is striking. On the left of the screen, we have a lamp, in the background some cupboards, and to the right of the screen the silhouette of Mac. In the middle of our field of view, as if by an accident in appearances, stands the disfigured and wholly alien materiality of the thing, its face a crude imitation of Norris, now traumatised by its own transformation. As Mac torches the abomination, the original head of Norris begins to dispatch itself from the dead corpse. Its head falls from the table, but instead of lying inert, the thing crawls across the floor thanks to the sudden growth of an elasticised tongue. As it becomes mobile, the head undergoes yet another stage in its becoming. Suddenly, six legs sprout from the skull, establishing a violent rebirth that finally dispenses with the subjectivity of Norris. What we are now faced with is a head-spider hybrid, a symbiotic organism that fulfils the legacy of Merleau-Ponty's "strange kinship" between the animal and the human (Merleau-Ponty 2003, 214). At first, none of the men notice the new organism. But then it tentatively appears from beneath the desk and scuttles into an adjacent storeroom, leading one of the characters to remark aptly: "You gotta be fucking kidding."

XVI

The relentlessness of the body and its refusal to die. Already this living death finds its articulation in the experience of the body itself. A blind elemental force—be it anxiety or nature—erupts violently. In each case, the body, and each of the body parts, becomes the accidental means through which life finds the opportunity to disguise and reveal itself. This gesture of blindness becoming-visible contains the germ of the uncanny. For what is at stake in the materialization of life is the revelation of the natural world as the site, not of a malevolent teleology, but of a teleology with no purpose, as evident in the indifference of the Lovecraftian cosmos as it is in the habits of corporeal existence. As Schopenhauer revealed long before Freud, organic existence, far from being subservient to the intellect, is in fact the primary constituent of the intellect, such that "mind" is an offspring of the persistence of matter. Blood itself, for Schopenhauer, is the most immediate expression of a blind willing, which objectifies itself first through vessels and then through the muscles more broadly. From nowhere, this primordial blood, itself a manifestation of a blind will, forges the entire nervous system by instinct. The brain, meanwhile, appears as nothing more than "a tentacle or feeler, the nerves of sense that it stretches and extends into the external world" (Schopenhauer 1966, 256). Visibility and the image of the body are inherently otherworldly and uncanny, given that the appearance of organic existence is the expression of that which lies beyond the body, and is thus already a transgression of the limits of matter. If there is a freedom in materiality, then it is only with respect to the reflexive gesture of catching sight of corporeality as the basis of an ungovernable realm of indifference, on which reflection is retroactively planted.

XVII

The end comes as the flesh awakens. It takes place in the basement of the camp, the spatial equivalent of the unconscious, complete with eerie lighting, hidden alcoves, chairs piled on chairs, dripping pipes, and buried secrets. Down there, in the depths of a place which, as Bachelard has it, "cannot be civilized," and where we must always carry a candle with us, the men wait (Bachelard 1994, 19). Suddenly the floor is unearthed, the thing makes its final appearance: a synthesis of its evolution, a formless and grotesque realisation of matter itself. Its emergence is interrupted as Mac tears the thing apart with dynamite. The snowy night is lit with a glaring explosion from below. What remains in the fallout is not the supremacy of evil, but the ambiguity of silence, a silence in which the human/non-human distinction retains its vagueness, leaving our traumatised survivor to remark mournfully: "Why don't we just wait here for a while… see what happens." This is the end as an impasse, as a protraction. It affords no resolution, less still any sense of optimism. Rather, when the end comes, it does so as the unfinished residue of the present. In this ambiguity, there is a moment of resigned acknowledgement by the two survivors of the thing that no matter how much we try to resist the flesh, the flesh of the thing remains a part of our escape route—marking the very materiality of both our survival and our evasion.

XVIII

In a conception of a world without humans, we are often met with the seductive image of a ruined Earth. Devoid of its people, the Earth not only persists but actively flourishes without us. Against the charred horizon of a world reclaimed by nature, its once monolithic towers become artefacts for future species to discover. Of its remaining cities, many have been consumed by

the oceans, becoming fragments in the basin of Earth. In all this ruin, the experience of humility in the present reigns supreme. Awakened to our radical finitude, the value of the Earth as a living organism is restored. Such is the strange logic inherent in this posthuman phantasy, which at all times seeks to reinforce rather than undermine the relational knot between subject and world by its ruin. In our unhuman phenomenology, we have conceptualized the Earth not as the objectification of a depopulated planet surveyed from the perspective of a speculative geology, but as a formlessness inherent in matter itself. Thus, to speak of the horror of the body, is also to speak of the horror of the cosmos. The horror comes to us in the figure of the flesh, an anonymous element which both reveals and conceals itself in all things, transforming the human body from a centre of experience to an organon of the deep past. Ours is a horror, therefore, that lies not in a future extinction but in an origin anterior to ourselves. From this origin, we have encountered the unhuman realm manifest precisely at the edge of experience, as that which evades language, reshapes subjectivity, and, finally, establishes itself as that most familiar thing—*the body*.

Notes

This book was made possible thanks to funding from both the Irish Research Council and the support of the School of Philosophy, University College Dublin. I acknowledge their support with gratitude. The germs of this book were conceived at both the Centre de Recherche en Epistémologie Appliquée and Les Archives Husserl, École Normale Supérieure, Paris. My thanks to Dorothée Legrand at both institutions for her dialogue throughout the writing of this book and beyond. In relation, thanks to Gabriel Catren for several suggestions concerning cosmic phenomenology. Additional thanks to Gregory Chatonsky and Dominique Sirois for permission to use an image from the *Telofossils* artwork for the cover image.

My thanks to Liam Sprod for proofreading the text. Special thanks to Orion Edgar for once more casting his diligent eye over the manuscript. Any errors that remain are, of course, my own responsibility. My final thanks to Audrey Petit for sharing "le silence éternel de ces espaces infinis" with me.

A modified version of chapter two originally appeared in *Speculations* as "The Horror of Darkness: Toward an Unhuman Phenomenology" (Vol. IV, pp. 113-121). In addition, a section from chapter three was originally published in *Film-Philosophy* as "The Return of the New Flesh: Body Memory in David Cronenberg and Merleau-Ponty" (Vol. 15:1, pp. 82-99). My thanks to the editors of both of these journals for permission to reproduce the parts in question.

1. The text of Clinton's speech can be found here: http://www2. jpl.nasa.gov/snc/clinton.html
2. See: http://www.nytimes.com/2013/02/07/science/living-bact eria-found-deep-under-antarctic-ice-scientists-say.html?_r=0
3. Herzog's account of truth is worth noting and bears

relevance to our engagement with science. Against the philosophy of *cinéma vérité*, Herzog outlines an alternative account of the relation between cinema and truth. For him, the role of cinema is not to produce truth as a question of factual data, but instead to frame film as an exploration situated at the intersection of the imaginary and the factual (Herzog 2002, 240). One striking example of this ecstatic notion of truth is clear in the opening scene of his film, *Lessons of Darkness* (1992). The film begins with a citation attributed to Pascal: "The collapse of the stellar universe will occur—like creation—in grandiose splendour." In fact, the quote is written by Herzog in order to set the appropriate tone for the film. On its usage, he explains: "We are immediately in the realm of poetry—whether or not the audience knows the quote is a fake—which inevitably strikes a more profound chord than mere reportage" (243). This elevation of fact is evident in our own reading of Martian meteorites. What we are concerned with is not the precise chemical and organic structure of the object, but its status within the realm of the imaginary, even to the extent of underplaying the object's factual status.

4. In Martin's *Horror Express*, horror's relation to ancestrality is especially clear in the final scenes. As with Carpenter's *The Thing*, the arc of the film concerns the reanimation of an entity frozen in space and time. Once reanimated on board the Trans-Siberian Express from China to Moscow, the thing reveals itself, explaining: "I am a form of energy occupying this shell. [I come from] another galaxy... I was left behind, an accident. I survived in protozoans, fish, vertebrates. The history of your planet is part of me." Needless to say, such motifs find their genesis in Lovecraft's *At The Mountains of Madness*, which while not discussed explicitly in this book, is implicit throughout (Lovecraft 2008).

5. Nowhere is this relation between space and hauntings

clearer in Kubrick's film than in the scene where the remark is made to Jack Torrance: "You've always been the caretaker." Rightly, this phrase has been assigned a central place in studies of Kubrick's film, given that the structure of the film's hauntings are located in this motif. (Cf. Trigg 2014).

6. Abram's treatment of Merleau-Ponty is especially notable for its disingenuous appeal to an ethical structure that is nowhere to be found in Merleau-Ponty. For example, on the role of anonymity of the Earth and nature in Merleau-Ponty, Abram writes that "Merleau-Ponty had to write in this way because what was anonymous then did not finally lose its perpetual anonymity until a decade after his death, when the first clear photographs of the Earth viewed from space were developed, and our eyes caught sight of something so beautiful and so fragile that it has been known to bring a slight reordering of the senses" (Abram 1997, 88). On this interpretation, Abram's misreading is inaccurate to the point of obscurity. As we see throughout the present book, at stake in Merleau-Ponty's account of the anonymity of nature is not a perceptual oversight, or an oversight that contingently hinges upon empirical data. Rather, what Merleau-Ponty is describing is fundamentally an ontological anonymity.

7. For an extended analysis of this conceptual and historical importance of the meeting, see Vrahimis 2013.

8. Merleau-Ponty's reading of Schelling in these sections is, as Dominique Séglard tells us, indebted to Löwith's treatment of Nietzsche in *Nietzsche, Philosophy of the Eternal Recurrence of the Same* (Löwith 1997; Merleau-Ponty 2003, 290). It is in this latter work, that Löwith will speak of Schelling as presenting the "basic material of all life [as] the terrible" (149).

9. On the relationship between spaceflight and bodily disintegration, it would be remiss not to mention William Sachs's

The Incredible Melting Man (1977). The film is inspired in part by Val Guest's *The Quatermass Xperiment* (1955), which tells the story of an astronaut who returns to Earth possessed by an alien infection, which threatens to destroy humanity. While the earlier version of this story is superior in almost every respect, Sachs's later recasting of the plot is notable as a grotesque exaggeration of Ballard's so-called Cape Canaveral Stories, depicting the effect of what happens to the human body after it is exposed to radiation during a voyage to Saturn. The film strikingly confronts the viewer with the prospect that spaceflight not only estranges the astronaut from the Earth, but also violates the transcendental bond between body and ground, as depicted in Husserl. Indeed, in the film, the astronaut who returns to the Earth after his aborted voyage to Saturn, is returned as a disfigured semi-human entity, driven by the bloodlust of an uncivilized *id*. By the end of the film, this bloodlust is consummated in the image of human flesh slowly falling away from the bones, thus preparing the ground for a post-human entity. As if to emphasize the contingency of the flesh, the film concludes with the image of the astronaut's discarded flesh being casually mopped into a bin by a passing cleaner.

10. Val Guest's *The Quatermass Xperiment* provides us with a clear definition of such an abject notion of life, as a character remarks of the origin of life: "What if there is a form of life in space, not on some planet, just drifting... Not life as we know it, with intelligence yes, but a pure energy with no organic structure, invisible." The horror of such a libidinous form of life is that it is not only directed toward the colonization of human body, but of all matter, both animal and plant. Thus, at one point in the film, the distinction between the two aspects is confused through the use of an image of a human with a cactus growing from his arm.

Works Cited

Abram, David. 1997. *The Spell of the Sensuous: Perception and Language in a More-than-Human World*. (New York: Vintage Books).

Bachelard, Gaston. 1994. *The Poetics of Space*. Trans. Maria Jolas. (Boston: Beacon Press).

Ballard, J. G. 2006. *The Complete Short Stories, Volume 2*. (New York: Harper Perennial).

Barnes, Jonathan. 1987. *Early Greek Philosophy*. (Harmondsworth: Penguin).

Bataille, Georges. 1986. "Un-knowing and its Consequences." Trans. A. Michelson. *October*, 36:80–85.

Cronenberg, David. 1997. *Cronenberg on Cronenberg*. (London: Faber & Faber).

Cronenberg, David. 2006. *Interviews with Serge Grünberg*. (London: Plexus).

Deleuze, Giles. 2005. *Francis Bacon: The Logic of Sensation*. Trans. Daniel Smith. (London and New York: Continuum).

Freud, Sigmund. 2003. *The Uncanny*. Trans. David McLintock. (Harmondsworth: Penguin).

Herzog, Werner. 2002. *Herzog on Herzog*. (London: Faber & Faber).

Jonas, Hans. 2001. *The Phenomenon of Life: Toward a Philosophical Biology*. (Evanston: Northwestern University Press).

Kristeva, Julia. 1982. *The Power of Horror: an Essay on Abjection*. Trans. Leon S. Roudiez. (New York: Columbia University Press).

Lacan, Jacques. 1991. *The Ego in Freud's Theory and in the Technique of Psychoanalysis*. Trans. Sylvana Tomaselli. (New York: Norton and Company).

Lacan, Jacques. 1997. *The Ethics of Psychoanalysis*. Trans. Dennis Porter. (New York: Norton and Company).

Lacan, Jacques. 2006. *Séminaire XVI: D'un Autre à l'autre*. (Paris: éditions du Seuil).

Levinas, Emmanuel. 1990. *Difficult Freedom*. Trans. Sean Hand. (Baltimore: Johns Hopkins University Press).

Levinas, Emmanuel. 2001. *Existence and Existents*. Trans. Alphonso Lingis. (Pittsburgh: Duquesne University Press).

Levinas, Emmanuel. 1985b. *Ethics and Infinity*. Trans. Richard Cohen. (Pittsburgh: Duquesne University Press).

Levinas, Emmanuel. 1989. *The Levinas Reader*. Ed. Sean Hand. (Oxford: Blackwell Press).

Levinas, Emmanuel. 1985a. *Time and the Other*. Trans. Richard Cohen. (Pittsburgh: Duquesne University Press).

Levinas, Emmanuel. 1969. *Totality and Infinity: an Essay on Exteriority*. Trans. Alphonso Lingis. (Pittsburgh: Duquesne University Press).

Locke, John. 1993. *Essay Concerning Human Understanding*. (London: Orion Books).

Lovecraft, H. P. 2008. *Necronomicon*. (London: Gollancz).

Löwith, Karl. 1997. *Nietzsche, Philosophy of the Eternal Recurrence of the Same*. Trans. Harvey Lomax. (Berkeley: University of California Press).

Lucretius. 1994. *On the Nature of the Universe*. Trans. R. E. Latham. (Harmondsworth: Penguin).

Lyotard, Jean-Francois. 1991. *The Inhuman: Reflections on Time*. Trans. Geoffrey Bennington and Rachel Bowlby. (London: Polity Press).

Madison, Gary Brent. 1990. *The Phenomenology of Merleau-Ponty: A Search for the Limits of Consciousness*. (Athens: Ohio University Press).

Meillassoux, Quentin. 2008. *After Finitude: an Essay on the Necessity of Contingency*. Trans. Ray Brassier. (London: Continuum Press).

Merleau-Ponty, Maurice. 2002. *Husserl at the Limits of Phenomenology*. Ed. Leonard Lawlor and Bettina Bergo. Trans.

John O'Neill et al. (Evanston: Northwestern University Press).

Merleau-Ponty, Maurice. 2003. *Nature: Course Notes from the College de France.* Trans. Robert Vallier. (Evanston: Northwestern University Press).

Merleau-Ponty, Maurice. 1970. *The Concept of Nature, I, Themes from the Lectures at the Collège de France 1952–1960.* Trans. John O'Neil. (Evanston: Northwestern University Press).

Merleau-Ponty, Maurice. 2006. *The Phenomenology of Perception.* Trans. Colin Smith. (London: Routledge).

Merleau-Ponty, Maurice. 2012. *The Phenomenology of Perception.* Trans. Donald Landes. (London: Routledge).

Merleau-Ponty, Maurice. 1994. "Preface to Hesnard's *L'Oeuvre de Freud,*" in *Merleau-Ponty and Psychology.* Trans. Alden L. Fisher. (Atlantic Highlands: Humanities Press).

Merleau-Ponty, Maurice. 1964a. *The Primacy of Perception.* Trans. William Cobb. (Evanston: Northwestern University Press).

Merleau-Ponty, Maurice. 1965. *The Structure of Behaviour.* Trans. Alden L. Fisher. (Boston: Beacon Press).

Merleau-Ponty, Maurice. 1964b. *Signs.* Trans. Richard McCleary. (Evanston: Northwestern University Press).

Merleau-Ponty, Maurice. 1968. *The Visible and the Invisible.* Translated by Alphonso Lingis. (Evanston: Northwestern University Press).

Pascal, Blaise. 1973. *Pensées.* Trans. John Warrington. (London: Dent and Sons).

Schelling, F. W. J. 2007. *Philosophical Investigations into the Essence of Human Freedom.* Trans. Jeff Love and Johannes Schmidt. (New York: SUNY Press).

Schelling, F. W. J. 1859. *Sämmtliche Werke.* Ed. Karl Friedrich August Schelling. (Stuttgart: Augsburg).

Schelling, F. W. J. 1942. *The Ages of the World.* Trans. F. Bolman. (New York: Columbia University Press).

Schelling, F. W. J. 1997. *The Ages of the World.* Trans. Judith Norman. (Michigan: University of Michigan Press).

Schopenhauer, Arthur. 1966. *The World as Will and Representation*. Trans. E. F. J. Payne. (New York: Dover).

Sparrow, Tom. 2013. *Levinas Unhinged*. (Winchester: Zero Books).

Trigg, Dylan. 2012. *The Memory of Place: a Phenomenology of the Uncanny*. (Athens: Ohio University Press).

Trigg, Dylan. 2014. "Archaeologies of Hauntings: Phenomenology and Psychoanalysis in *The Shining*" in *The Shining: Studies in the Horror Film*. Ed. Danel Olson. (Colorado: Centipede Press, Forthcoming).

Vallier, Robert. 2009. *Merleau-Ponty and the Possibilities of Philosophy*. (New York: SUNY Press).

Vrahimis, Andreas. 2013. *Encounters Between Analytic and Continental Philosophy*. (London: Palgrave).

Filmography

Baker, Roy Ward. 1967. *Quatermass and the Pit*. DVD. (Paris: Studio Canal).

Carpenter, John. 1982. *The Thing*. DVD. (London: Universal Pictures).

Carpenter, John. 1987. *Prince of Darkness*. DVD. (London: Universal Pictures).

Carpenter, John. 1995. *In the Mouth of Madness*. DVD. (Los Angeles: New Line Home Video).

Carpenter, John. 1979. *The Fog*. DVD. (London: Optimum Home Releasing).

Carpenter, John. 1984. *Christine*. DVD. (California: Sony Pictures).

Cronenberg, David. 1979. *The Brood*. DVD. (Beverly Hills: Anchor Bay).

Cronenberg, David. 1983. *The Dead Zone*. DVD. (Denmark: Scanbox Entertainment).

Cronenberg, David. 1986. *The Fly*. DVD. (Los Angeles: 20th Century Fox).

Cronenberg, David. 2006. *A History of Violence*. DVD. (Los Angeles: New Line Cinema).

Frances, Freddie. 1973. *The Creeping Flesh*. DVD. (California: Sony Pictures).

Franju, Georges. 1960. *Les yeux sans visage*. DVD. (London: Second Sight Films).

Friedkin, William. 1973. *The Exorcist*. DVD. (Burbank: Warner Home Video).

Guest, Val. 1955. *The Quatermass Xperiment*. DVD. (London: 2 Entertain Video).

Herzog, Werner. 1992. *Lessons of Darkness*. DVD. (Beverly Hills: Anchor Bay).

Kubrick, Stanley. 1980. *The Shining*. DVD. (Burbank: Warner

Home Video).

Martin, Eugenio. 1972. *Horror Express*. DVD. (London: 2 Entertain).

Russell, Ken. 1980. *Altered States*. DVD. (Burbank: Warner Home Video).

Sachs, William. 1977. *The Incredible Melting Man*. DVD. (New York: Video International).

Scott, Ridley. 2012. *Prometheus*. DVD. (Los Angeles: 20th Century Fox).

Tarkovsky, Andrei. 1972. *Solaris*. DVD. (London: Artificial Eye).

Contemporary culture has eliminated both the concept of the public and the figure of the intellectual. Former public spaces – both physical and cultural – are now either derelict or colonized by advertising. A cretinous anti-intellectualism presides, cheerled by expensively educated hacks in the pay of multinational corporations who reassure their bored readers that there is no need to rouse themselves from their interpassive stupor. The informal censorship internalized and propagated by the cultural workers of late capitalism generates a banal conformity that the propaganda chiefs of Stalinism could only ever have dreamt of imposing. Zer0 Books knows that another kind of discourse – intellectual without being academic, popular without being populist – is not only possible: it is already flourishing, in the regions beyond the striplit malls of so-called mass media and the neurotically bureaucratic halls of the academy. Zer0 is committed to the idea of publishing as a making public of the intellectual. It is convinced that in the unthinking, blandly consensual culture in which we live, critical and engaged theoretical reflection is more important than ever before.